WILD + FREE
HANDCRAFTS

WILD + FREE HANDCRAFTS

32 Activities to
Build Confidence,
Creativity, and Skill

AINSLEY
ARMENT

HarperOne

WILD + FREE HANDCRAFTS. Copyright © 2020 by
Ainsley Arment. All rights reserved. Printed in
Canada. No part of this book may be used or
reproduced in any manner whatsoever without
written permission except in the case of brief
quotations embodied in critical articles and reviews.
For information, address HarperCollins Publishers,
195 Broadway, New York, NY 10007.

HarperCollins books may be purchased for
educational, business, or sales promotional use.
For information, please email the Special Markets
Department at SPsales@harpercollins.com.

FIRST EDITION

Designed by Janet Evans-Scanlon

Library of Congress Cataloging-in-Publication Data
Names: Arment, Ainsley, editor.
Title: Wild and free handcrafts : thirty-two activities to build
 confidence, creativity, and skill / Ainsley Arment.
Description: First edition. | New York, NY : HarperOne, 2020
Identifiers: LCCN 2019049240 (print) | LCCN 2019049241 (ebook) | ISBN
 9780062916556 (trade paperback) | ISBN 9780062916563 (ebook)
Subjects: LCSH: Handicraft—Handbooks, manuals, etc. | Parent and child.
Classification: LCC TT155 .W455 2020 (print) | LCC TT155 (ebook) | DDC
 745.5—dc23
LC record available at https://lccn.loc.gov/2019049240
LC ebook record available at https://lccn.loc.gov/2019049241

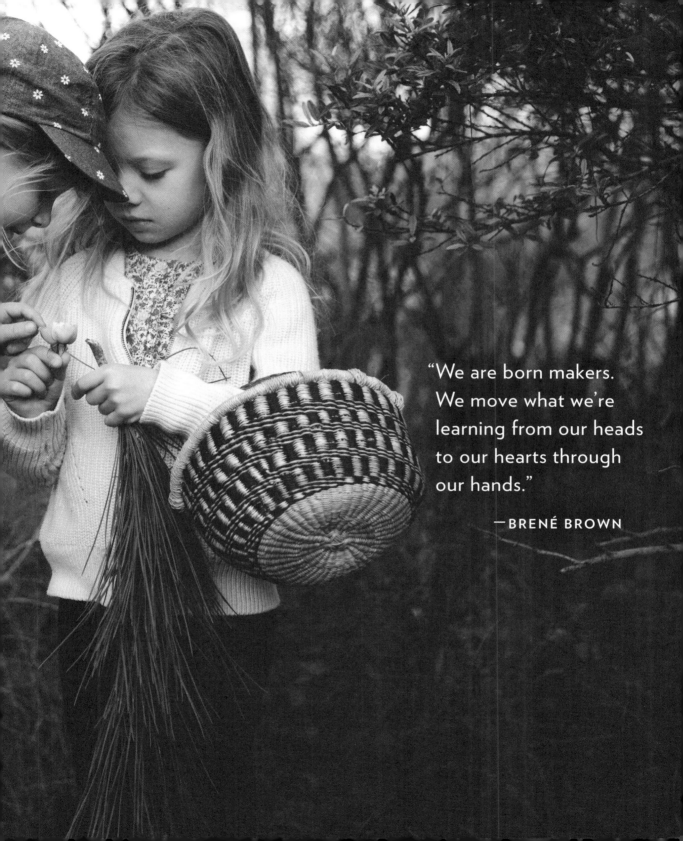

"We are born makers. We move what we're learning from our heads to our hearts through our hands."

—BRENÉ BROWN

CONTENTS

For the Love of Handcrafts by Ainsley Arment ix

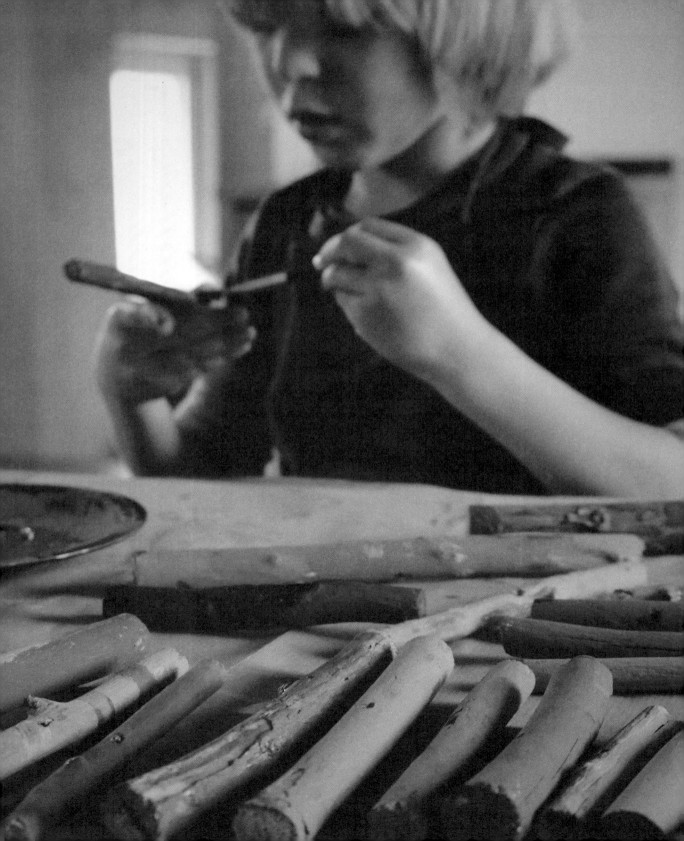

FOR THE LOVE OF HANDCRAFTS

watched as my son concentrated on his hand, weaving the yarn around each finger, then looping it around his pinkie to continue the weave. Finger knitting was new to both of us, but he was determined to learn. At nine years old, he needed to work with his hands to stave off boredom and, even more, to keep his mind active.

I've found that too often kids are told to keep their hands and bodies under control.

"Sit still," they're told.
"Stop moving."
"Sit on your hands if you have to."

But children's hands need to move in order for them to learn. By telling our kids to sit still or stop moving, we are really telling them to shut down their brains and stop learning.

Engaged hands equal engaged minds.

Saint Francis of Assisi said, "He who works with his hands is a laborer. He who works with his hands and his head is a craftsman. He who works with his hands and his head and his heart is an artist."

As a mama, I want to encourage my children to be *artists*, which is why handcrafts are of such importance in our home.

A handcraft is any activity that engages one's hands, requires a level of learned skill, encourages children to do their best work, and produces an end product that is useful. A few examples are woodworking, sewing, scrapbooking, crocheting, painting, leather tooling, quilting, pottery, calligraphy, knitting, flower arranging, and iron sculpting. Let's not forget that usefulness is in the eye of the beholder. If beauty

is the purpose of your creation, then it qualifies as a handcraft.

This book is a collection of handcraft tutorials from Wild + Free, a community of mothers and parents who are reclaiming wonder in their children's education. Each tutorial has been created and tested by families with kids who vary in age, interests, and geographic location. Structured seasonally, these crafts are designed to be undertaken throughout the year.

I've included a range of projects from easier handcrafts that are fun and skill-building to more challenging works that require additional effort, practice, and passion. Look for the icon next to each craft that indicates whether the project is better for beginning (easy enough for young children to do with minimal help and supervision), intermediate (some adult participation and supervision needed), or advanced crafters (adult participation or supervision needed).

Beginner

Intermediate

Advanced

I've also included a Resources and Materials section on page 135 that will direct you to where you can buy the supplies needed for these projects, as well as a suggested list of items to stock in your handcraft supply cabinet.

Whether your children make felted acorns, paper beads, or bug hotels, I hope this book inspires you to help them create beauty, as well as offering them opportunities to work with their hands and discover a skillful craft they love to practice. Most of all, I hope these enriching activities from the lost art of handcrafts spark delight for you and your kids.

AINSLEY ARMENT
Editor

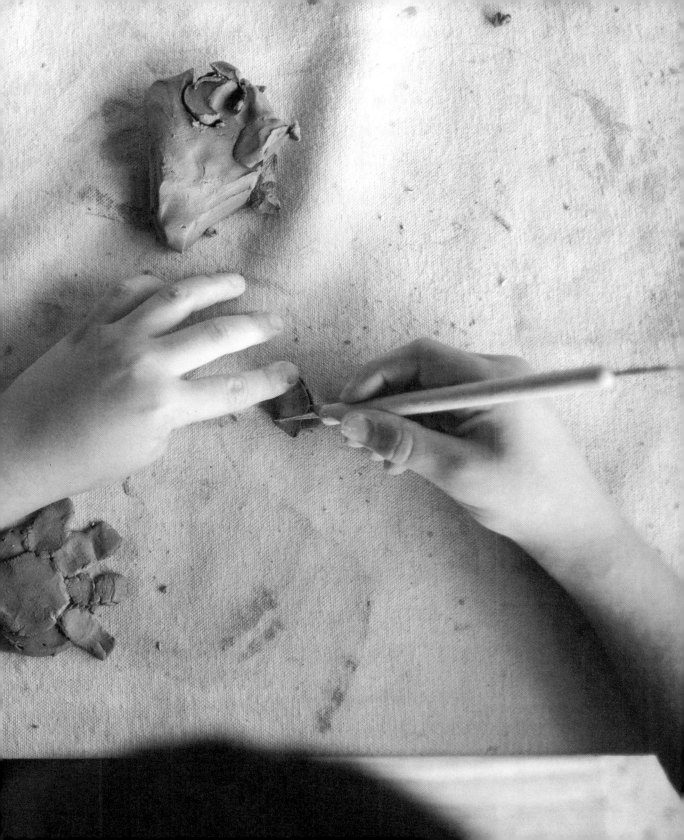

AUTUMN

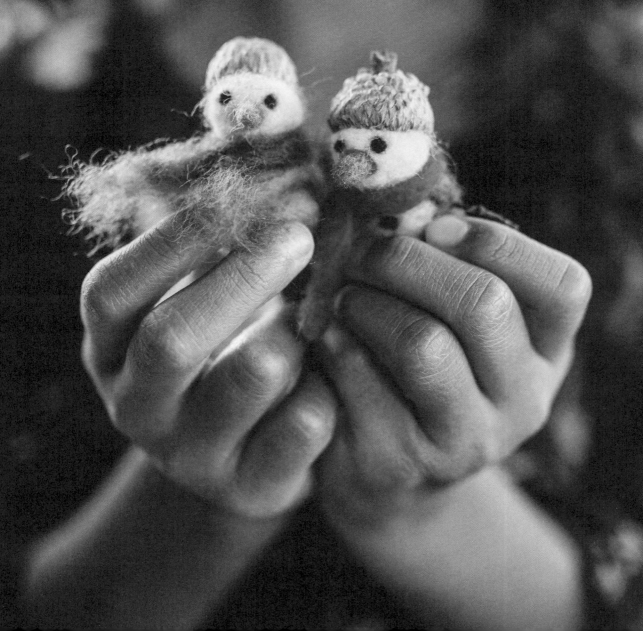

FELTED ACORNS

One of my family's favorite things to do in the fall is to go on nature walks and collect acorn caps. We often go to a local park that has giant, majestic oak trees with widespread branches, where we enjoy listening to the sound of the falling acorns and the tap, tap, tapping of acorn woodpeckers.

There is a huge tree in the park whose trunk is covered in acorns. We learned that woodpeckers have chosen this tree as a granary, or storehouse, and that they store thousands of acorns in it each year. It is quite a sight to behold.

People are encouraged to collect the numerous acorns and acorn caps to take home. The first year we took whole acorns home with us, but we quickly learned that acorns often have weevil larvae living inside them, and since then we collect only the caps.

We enjoy using these acorn caps in our handcrafts. They can be used in a variety of ways, and so many beautiful projects can be made with them. One of my children's favorites is felted acorns. They are simple to make and can be used in garlands, as ornaments, as toppers for wrapped gifts, or simply placed in bowls for decor. We even gift them during the holidays.

This craft is proof that some of the best crafting materials are right outside our door! Creating with nature encourages our children to explore and promotes curiosity and discovery while also providing them with wonderful sensory experiences.

MATERIALS

Acorn caps

Wool roving in different colors

Felting needles (special needles with barbed blades)

Felting surface (thick foam pads work well; we use cutting mats under our foam pads to protect the surface we're working on)

Craft glue

SAFETY TIP

Felting needles can be dangerous and should be used with adult supervision. Protective finger guards can be found at craft stores.

INSTRUCTIONS

1. Tear off about a 6-inch piece of roving. Tearing rather than cutting works best.

2. Wrap the fluffy wool into a loose ball.

3. Place the ball on top of your felting surface and poke it with a felting needle to a depth of about ¼ inch.* Be sure to poke straight up and down. Your needle will come out more easily and there will be less chance of poking your fingers. Encourage children to work slowly and carefully.

4. As you poke your ball, the fibers of the roving will begin to felt together. Shape your roving into a ball as you work. Your ball will become firmer, smaller, and less fuzzy.

5. When you are happy with the shape of your ball, add an acorn cap to the top with a small amount of glue.

6. Holiday alternative: My children made needle-felted snowmen ornaments (as shown) to gift to family and friends. Take 2 felted wool balls, placing one on top of the other. Using your felting needle, poke some of the fibers from the top ball into the bottom ball until they feel securely connected. If using the wet method for felting, you can simply glue your two balls together. Then decorate your snowman and add a string if making an ornament!

* Instead of using a sharp felting needle, younger children can felt their roving by using warm soapy water (see Wet Felting Spring Animals on page 78). Fill a bowl with warm water and just a couple of drops of soap. Follow the first two steps above. Then dip your fluffy wool ball into the water and roll it between the palms of your hands. The wool will felt as it is rolled. Once you are happy with the shape of your ball, squeeze out the excess water and allow it to dry.

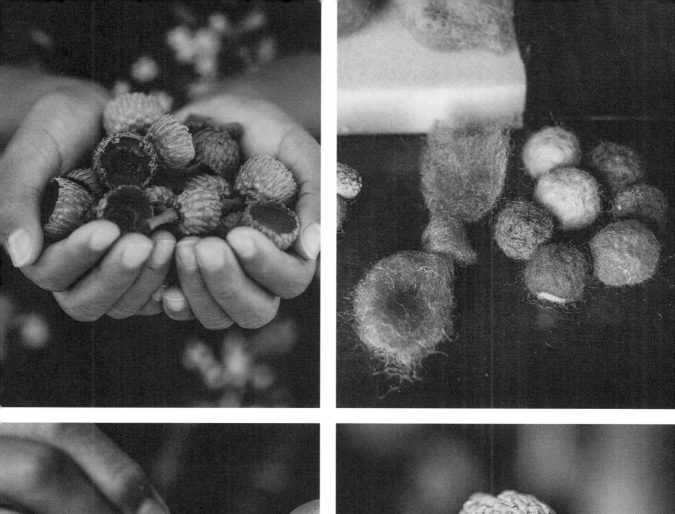
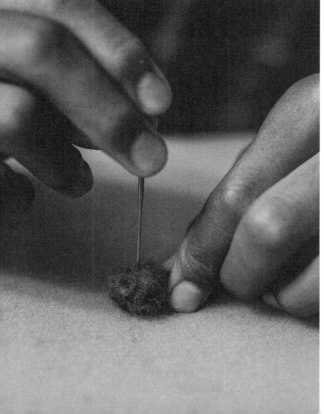
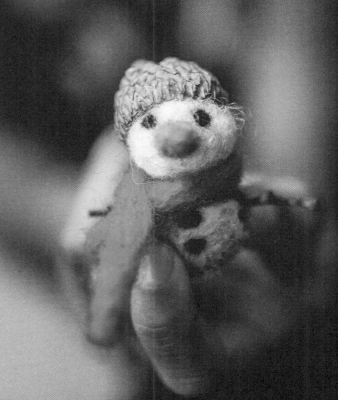

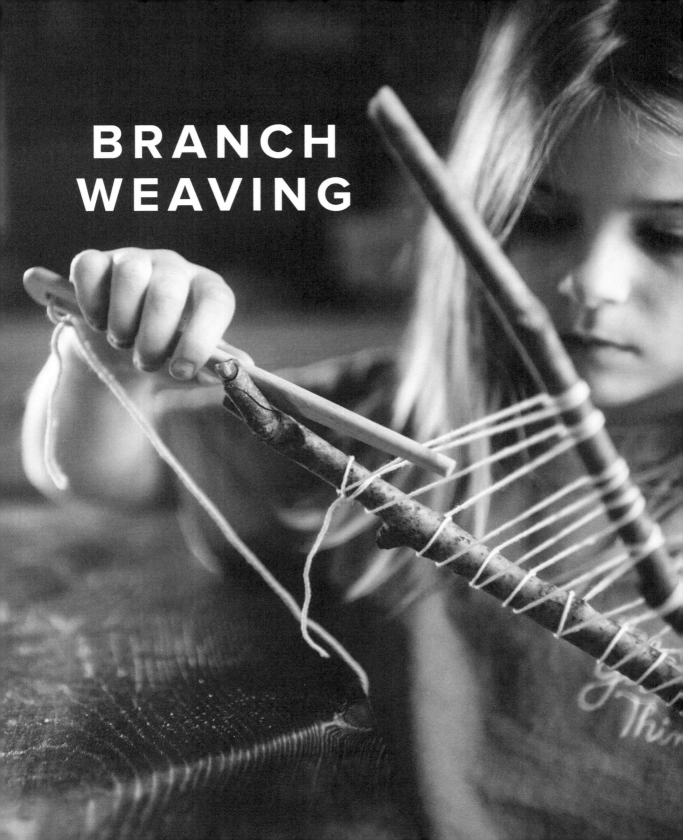

BRANCH
WEAVING

My kids and I always bring home nature treasures that we find on our daily walks, and branches are our favorite. After collecting quite a few, we started creating art with them. Not only does branch weaving make a unique wall hanging, but it is also the perfect way to keep my children's hands busy with nature on a rainy day.

MATERIALS

V-shaped branch

Yarn for weaving

String for making a warp

Tapestry needle (if you don't have a tapestry needle, small fingers work just as well)

Fork

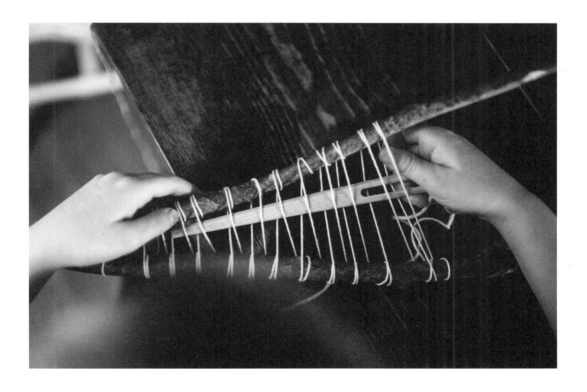

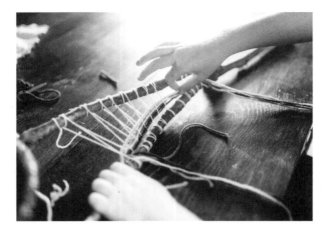

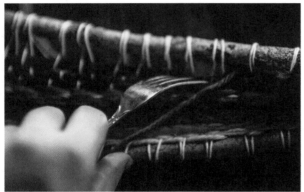

INSTRUCTIONS

1. Wind the string tightly around the branch to create a well-spaced warp, starting from the bottom of the V shape.

2. Once you create a warp, weave the yarn through it using fingers or a tapestry needle. Use a fork to push the weft down.

3. After you complete the weaving, turn the branch over and weave in any loose tails.

4. Add another piece of yarn to create a loop for hanging the finished piece.

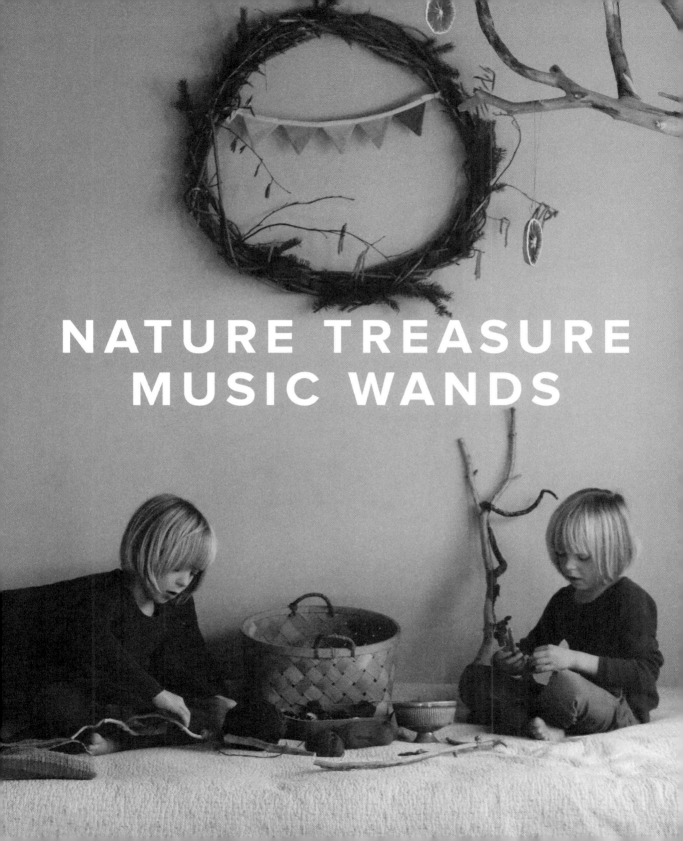

NATURE TREASURE
MUSIC WANDS

When my kids and I go out into the woods, I sometimes invite them to be absolutely still for a few minutes. We make a little circle holding hands, then sit or even lie down on the ground. Next, I tell them to close their eyes and open their hearts. After a brief moment of calm, I ask them what they hear.

The first thing they usually notice is their own silence, saying, "I don't hear anything!" When I offer a bit of help ("I hear the wind. It sounds as if he's playing a little game with the trees!" "And now a bird! What bird could it be? And what is her story?"), soon enough they discover that the woods (or the meadow or the park) isn't as quiet as they initially thought it to be.

Other times, I ask them to walk around by themselves for a few minutes and look for something special—a tree with a remarkable shape, a broken shell of a bird egg, a colored feather, a stick that looks like a snake, or maybe just a pretty flower. Afterward, we come together and show each other what we have found.

Those special finds often end up being carried home with us where we either add them to our seasonal wreath or display them on the table or a sunny windowsill. Later, I pack the most remarkable ones away in a box that I keep especially for when we need some little treasures to add to our nature crafts.

One of those crafts is what I call nature treasure music wands.

I made these wands for the first time when my twins were about three years old. It was a fun and evocative project to work on together, even if I had to do much of the assembling myself. They chose the colors of yarn, collected the nature treasures they wanted to add, did small bits of the wrapping, and then told me what to add where. Then we went out into the woods where we tried to re-create the sounds that we heard all around us: the crunching crackle as we walked through piles of fallen leaves, the lazy whisper of the late autumn breeze, the happy chatter of birds.

One day when my kids were older, we decided to make new wands. It was raining,

but the boys insisted on making them anyway, so we built a cozy nest on the daybed in the living room with some favorite leftovers from my yarn basket, a pair of scissors, some small bells and ribbons, and our special box of nature treasures and set to work.

It was amazing to see how much their skills had improved over the last two years, as they were now able to do almost everything by themselves, with only minimal help for stringing bells and securing tight knots and wraps where they had added some feathers or some pine and alder cones. As we worked side by side, I also realized how much their personalities showed in the style of their work and the choices they made.

The wands looked beautiful, and the boys were incredibly proud of what they made.

MATERIALS

The perfect stick

Yarn (leftover bits and pieces work well here)

Scissors

A few bells

continued

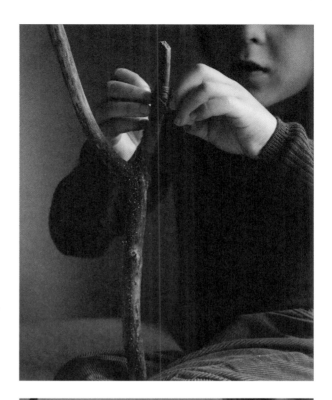

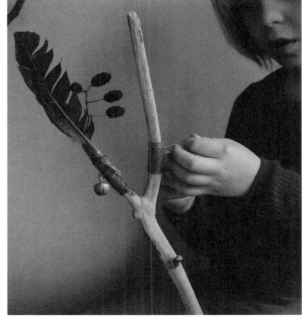

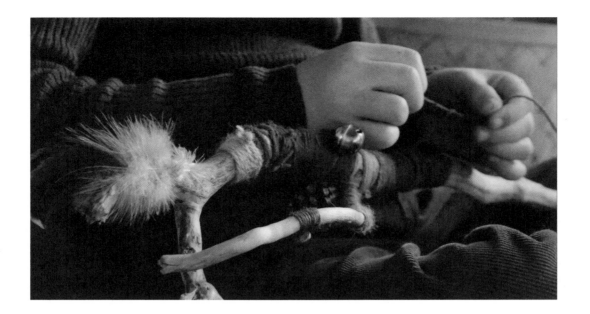

Small collection of nature treasures such as pine cones, dry leaves, feathers, little twigs, etc.

Optional: fine drill bit to bore holes in sea shells or pebbles

 SAFETY TIP

Drills can be dangerous and should be used with adult supervision.

INSTRUCTIONS

1. Cut a length of yarn and carefully wrap it around the stick, leaving a small tail that you can use to tie a knot with at the end. (Be sure to wind back a bit in the direction of the tail so as not to create a "yarn bridge" between the beginning and end, as these bits tend to loosen.)

You can make patterns like stripes and crosses by wrapping one color of yarn around the stick and then passing over it again with a contrasting color.

2. Once you are finished wrapping your stick, you can add bells or a few favorite pieces from your nature treasure collection to embellish the wands.

3. When you're done, take your music wand out into the woods, the park, or even to the beach to hear how its sweet sound intermingles with the music of Mother Nature herself.

HOMEMADE PAPER

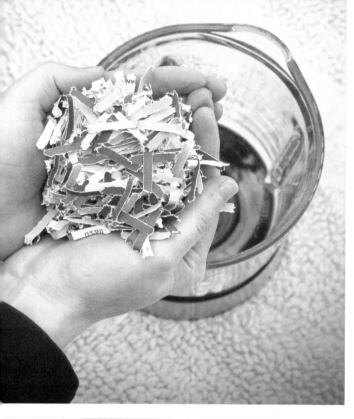
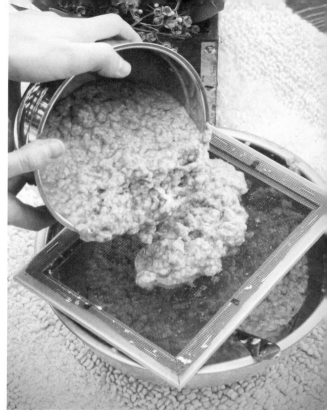
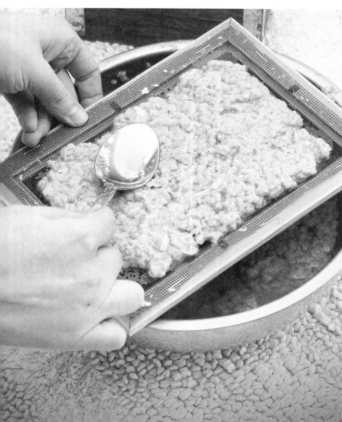

When I was young, during the long, hot days of summer I would make my own paper. Having been gifted a wooden deckle, I mashed paper scraps and gathered dried-up flowers from around our home to add beauty.

Now I enjoy making paper with my own children. It takes time, but the satisfaction of making the simplest of things is so gratifying.

MATERIALS

Wooden deckle or wooden frame with screen stapled on (having a piece of glass that goes with the frame is helpful)

Shredded paper

Dried flowers or herbs (I used lavender and wax flowers)

Blender

Bowl

Spoon

Water

Old dishcloth

Paper towels

 SAFETY TIP

Blenders can be dangerous and should be used with adult supervision.

INSTRUCTIONS

1. Take desired amount of paper and put it into the blender.

2. Cover with water, so about two-thirds of the paper is immersed. Blend.

3. Pour pulp into the deckle, held over a bowl to catch drips. Spread pulp out evenly with spoon into desired shape and thickness.

4. Use the glass to push the pulp down and strain the water out from the back of the deckle into the bowl.

5. Add in desired flowers and herbs. Cover slightly with pulp so they'll dry into the paper.

6. Put a few paper towels on top of the dishcloth and set the deckle on the paper towels. Let the pulp dry on the deckle for several days. Touch the pulp intermittently to see how dry it is.

7. Once you feel that the pulp has dried out well on one side, flip it over and let it dry on the other side. It may take several days, depending on thickness. It's normal for the paper to curl. Just lay it between some heavy books to flatten it out, and it's ready to use for various projects.

WHY WE DO HANDCRAFTS

BY RACHEL KOVAC

Each season, I introduce my children to a new handcraft, or we build upon the handcrafting skills they have previously acquired. I choose a project that will interest them, but one that is also useful. Care is taken to ensure they understand the new skill and that a sense of artistry is achieved. We go slowly rather than rush through. I want them to grasp, and ideally master, these techniques.

My kids might find these skills come in handy when they are adults someday. In that sense, they are learning life skills. But even if they have no interest in pursuing handcrafts in adulthood, they are learning grit and determination in the process.

The reason I introduce only one new handcraft quarterly is because I want my children to experience joy in working with their hands and the deep satisfaction that comes from creating projects that are self-led. Once they learn the skill, they have time to apply it to self-directed projects. For example, after I taught my children to hand-sew, the craft took on a life of its own. They started to sew bibs and clothes for their baby dolls, blankets, and even a purse. They enjoyed choosing their own fabrics and rummaging through my basket of trims to find the perfect accents.

In this case, most of the things they were making were not particularly useful. I wasn't hovering over them, critiquing their technique. But they discovered the thrill of making. They gained the skills to execute a project from start to finish, to see their vision become a reality. And they got a healthy dose of good, old-fashioned imaginative play.

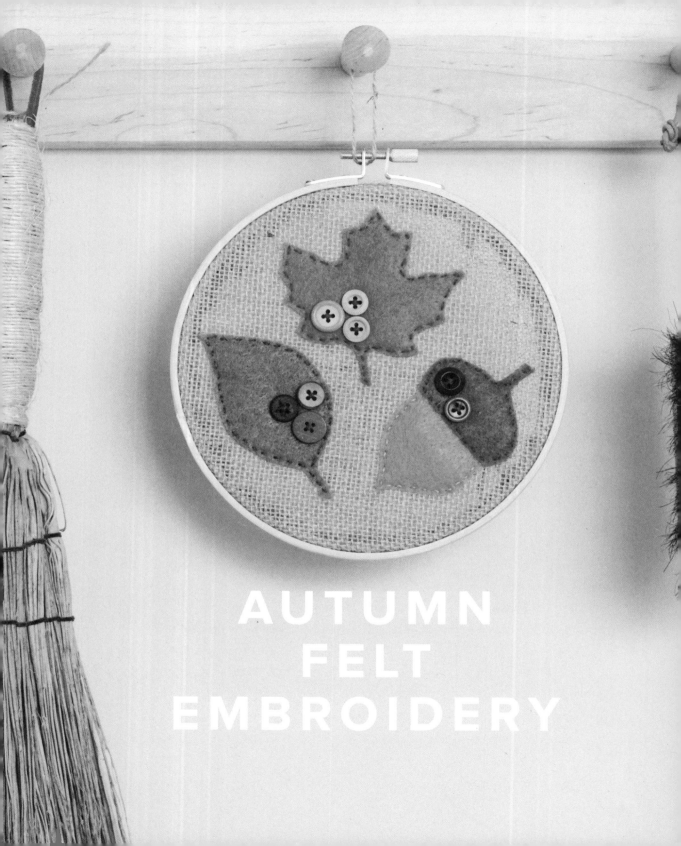

AUTUMN
FELT
EMBROIDERY

There's something about crisp, cool autumn air and the smell of pumpkin-everything that makes me want to curl up on the couch in my coziest sweater and work on a handcraft. It's even better when I can involve my children in the creative process.

Children of all ages can have fun participating in this festive craft, whether it's completing the project from start to finish, sewing on buttons, or simply choosing the colors of the felt and embroidery floss. This project can be tailored for any age, but sometimes it's rewarding to gently nudge and encourage our little ones beyond what they (or even we) think they are capable of doing.

MATERIALS

6-inch or 7-inch embroidery hoop
(the hoop will be a permanent part of
the finished product)

Burlap (to fit the embroidery hoop)

Cross-stitch or small tapestry needle (both
are blunt needles and work great with burlap)

Felt in various fall colors

Embroidery floss to match felt colors

Scissors

Hot glue gun

Fall-themed cookie cutters

Buttons

Twine for hanging finished product

Pen or pencil

Paper (for tracing a pattern onto)

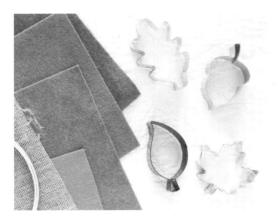

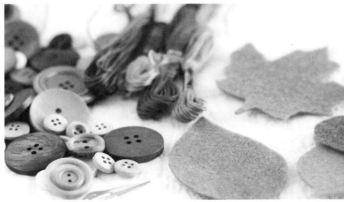

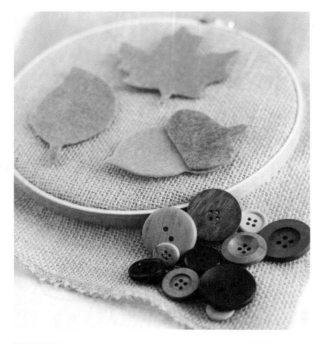

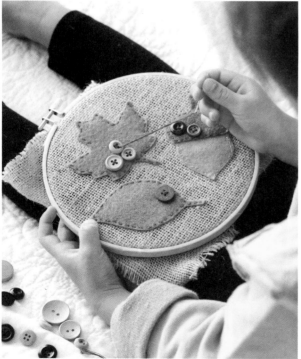

INSTRUCTIONS

1. Choose your cookie cutter and trace a cutout either directly onto the felt or onto a piece of paper to create a pattern. Then cut the felt into the desired shape.

2. Tighten the burlap into the embroidery hoop and place your cutouts where you want them.

3. Choose the embroidery floss that best matches the color of the cutouts and use the cross-stitch or tapestry needle to sew each cutout onto the burlap.

4. Sew buttons onto the cutouts in any desired pattern.

5. Once the craft is complete, trim the edges of the burlap, leaving about ½ inch of extra fabric around the outside of the hoop.

6. Using a hot glue gun, glue the burlap to the back edge of the hoop. Apply the glue to the hoop, not the burlap.

7. Using twine, hang your final product to be admired.

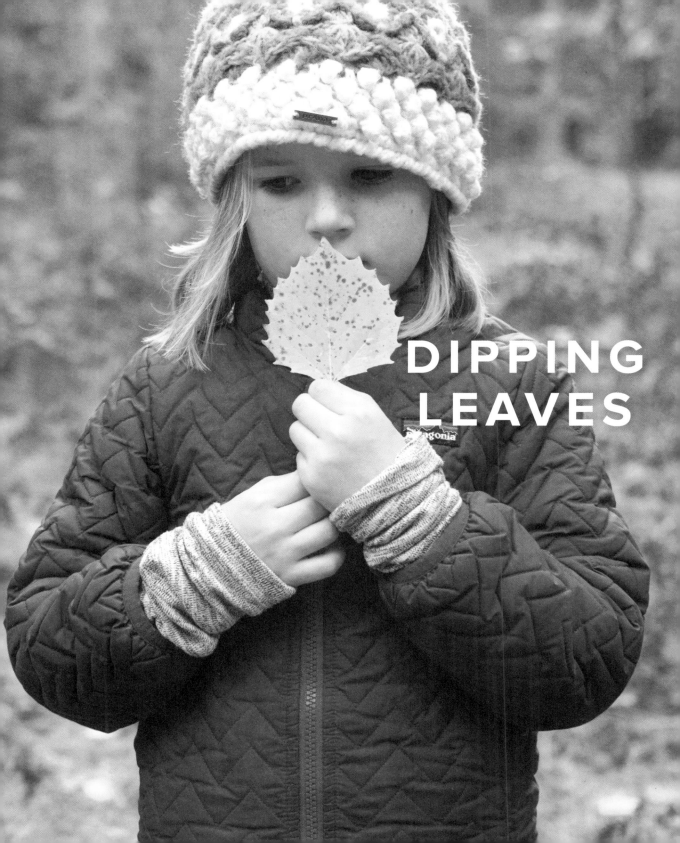

DIPPING
LEAVES

One beautiful fall day, my kids and I went outside to play in the leaves. We brought some leaves inside, and I remembered a project that I had read about: dipping leaves. After reading some instructions online, I filled a pot with chunks of raw beeswax, heating it slowly.

The aroma of melting wax, like honey and summer memories, filled the house. I coaxed my girls into the kitchen, and as we dipped our leaves into the beeswax, magic happened. We marveled as each leaf transformed into an object of shining light.

It has now become a simple yet treasured tradition in our family. One day last fall, the girls pulled out their baskets and went into the woods. I was preparing dinner in the kitchen when they returned with wild treasures: leaves of all colors and shapes. Maple. Ash. Birch. Chestnut. Poplar. Oak. It was as if the autumn woods had called out to them, yearning for the alchemy of melted beeswax. My girls remembered the smell and the whole process of waxy dipping. They asked to get out the beeswax

and began spreading their leaves across the counter. I love how special this craft has become to them, and it's something we treasure doing together each time the air turns cooler and the leaves start to drop.

You can use your dipped leaves in many creative ways. Make garlands of wax-covered leaves to hang in your windows. Use them as holiday ornaments. Decorate your Thanksgiving table with their vibrancy. Or simply place them in your favorite corners around the house. I hope these leaves can become a treasured family tradition for your family too.

MATERIALS

Leaves (as many as you'd like; start with a dozen or so)

¼ cup beeswax, about 2 ounces

Old slow cooker or double boiler (consider dedicating one to this use, as the wax is difficult to remove)

Newspaper or wax paper for the leaves to dry on

 SAFETY TIP

Heating elements and hot wax can be dangerous and should be used with adult supervision.

INSTRUCTIONS

1. Gather your leaves. Try to find a variety with the stems still attached. Stems will make the dipping easier.

2. Heat up your beeswax. Savor the aroma. We have a small slow cooker devoted to beeswax, but you can also use a double boiler on the stove. Find blocks of raw beeswax at farmers markets and natural food stores, or ask your local beekeeper.

3. Spread newspaper or wax paper over your work surface. Hold each leaf by its stem, dip it into the melted wax, and then pull it out slowly, letting the excess wax drip back into the pot. Let each leaf cool on the newspaper for a few minutes before you handle it again.

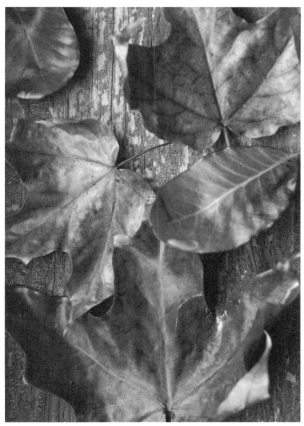

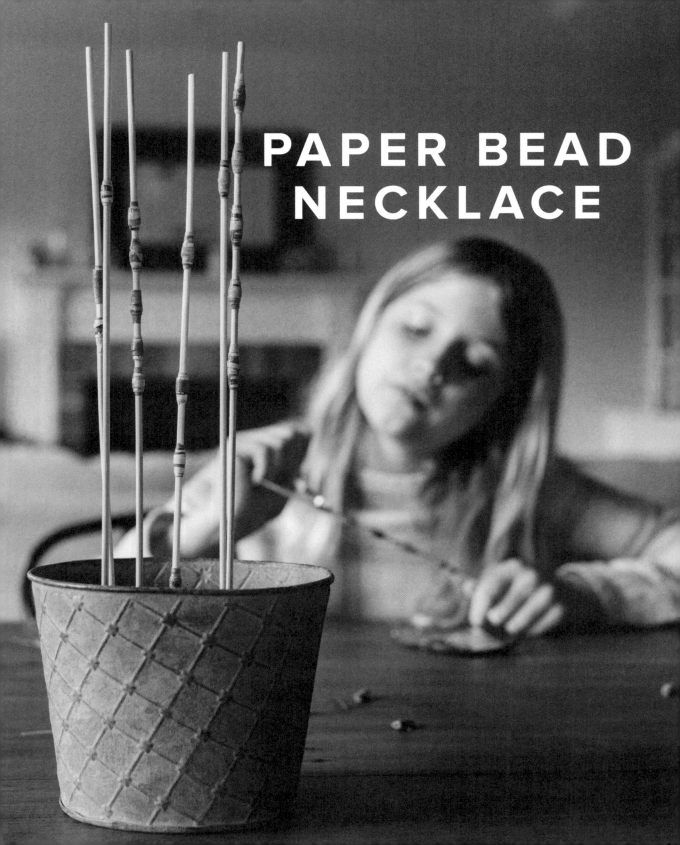

PAPER BEAD
NECKLACE

Making paper beads is a traditional craft that dates back to the Victorian era. Women would gather together socially and roll scraps of wallpaper onto knitting needles, forming beads. They would polish the beads with beeswax and string them onto long pieces of yarn. These beaded strands were used to make inexpensive curtains that divided rooms.

More recently, this handcraft has been revived in developing countries as a sustainable way to generate income. Women and children roll beads into various shapes and sizes using recycled newspapers and magazines to create jewelry that is sold in the marketplace. Sometimes the beads are painted. They are often sealed with varnish to make them both water-resistant and durable.

Stringing paper beads is a great way to spend an afternoon with your kids and results in brightly colored necklaces for wearing or giving as gifts!

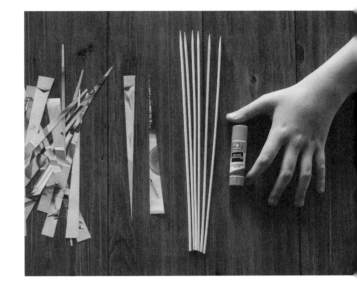

MATERIALS

Craft glue

Magazine paper (matte paper is easier to work with than glossy; thicker paper makes thicker beads)

A wooden skewer or knitting needle

Mod Podge® or any white glue thinned with water

String or yarn

Paintbrush

Scissors

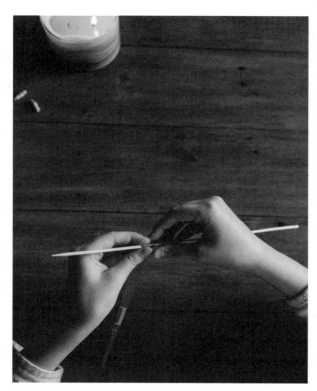
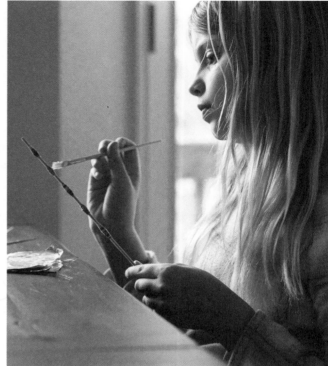

INSTRUCTIONS

1. Cut your magazine paper into triangles ½ inch at the base and 9 inches or longer in length.

2. Roll the base of the paper triangle around the skewer. Be sure to wrap the paper tightly so the bead doesn't unravel.

3. When you get close to the tip of the triangle (the last inch or so), add some glue and continue wrapping. Make sure the tip of the triangle is well glued so it doesn't unravel.

4. Leave the rolled beads on the skewer until it holds several beads.

5. Paint the beads with Mod Podge®. Avoid using too much or the beads will stick to the skewer and the paper will rip when you try to remove them. A thin layer will do.

6. Set the beads aside to dry. This usually takes about 3 hours. You can also come back to them the following day.

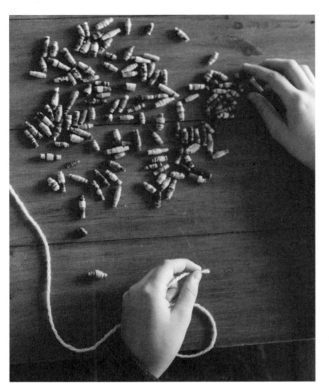

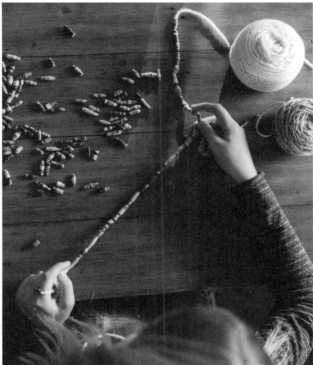

7. Once the beads are dry, remove them from the skewers. Sometimes the beads will stick to the skewer. If this happens, break the wooden skewer near the bead and the bead should slip off. If you are using a knitting needle, the beads should slide off easily.

8. Now you are ready for the best part: stringing the beads. Secure one bead at the end of the string or yarn so the other beads do not slip off.

9. If making a necklace, be sure the string is long enough to comfortably fit over the child's head when the project is complete.

10. Save your favorite, most-special beads for the center of the necklace where they will be most visible. Or you can turn these special beads into rings.

11. Be sure you like the placement of all your beads before you tie off the necklace.

12. Enjoy your necklace or give it to someone you love!

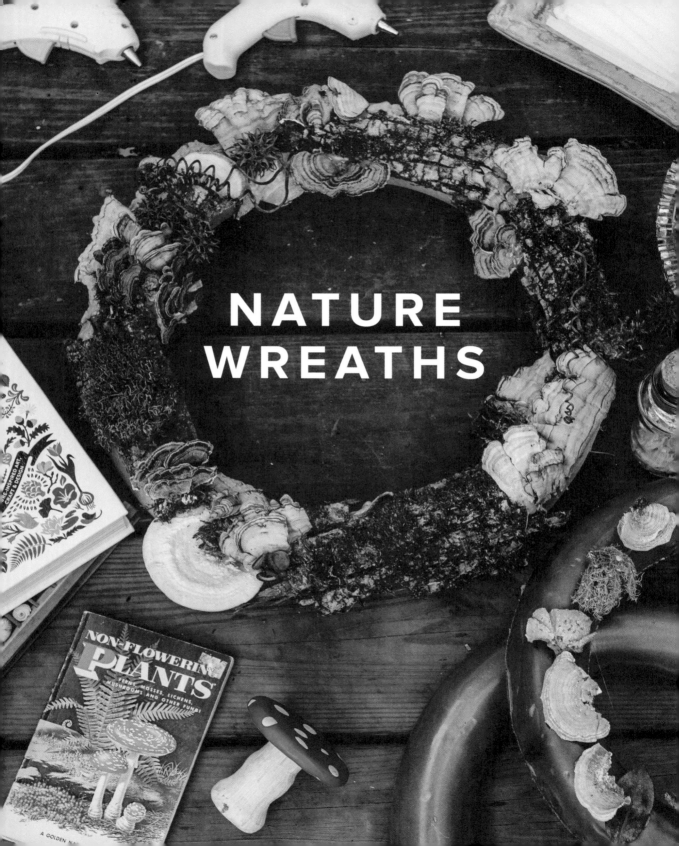

NATURE
WREATHS

A few months ago, I came across the most darling basket at a thrift store and it has become my family's dump station. We empty our pockets, backpacks, and bags into the basket; whatever we have collected on an adventure, in it goes! When our basket is full, we take it to the back deck and pull out all of our treasures (and sometimes a spider or two): bits of dried moss, turkey tail mushrooms, dried curly vines, sweet gum seed pods, tiny acorns, a few smashed pine cones. What is a mama to do with all of these sticks, moss, and acorns? Make a nature wreath!

My nature wreath has been on my front door since last winter, still holding strong. A darling little bird family "borrowed" all of the moss from it to build a nest on our front porch light. The wreath is still beautiful to me, and I smile each time I see it because it reminds me of the adventures I shared with my children.

A nature wreath is simple to make. Smaller wreaths are easier for young children, but larger wreaths give them more surface area to work with. And most of your materials are natural, such as sticks, moss, mushrooms, acorns, pine cones, feathers, rocks, crystals, fossils, shells, leaves, or anything that you respectfully and responsibly collect while out adventuring. By spending a little time studying where you live, searching, and collecting, you will have all the supplies you need to create something beautiful that represents your family's adventures.

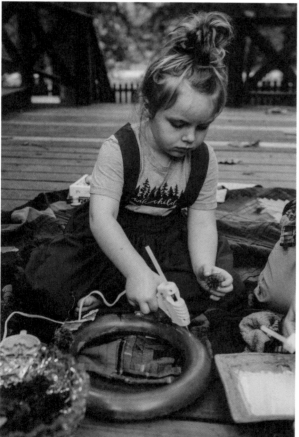

MATERIALS

Floral craft foam wreath

Moss or leaves

Large bowl of nature treasures

Hot glue gun

⊞ SAFETY TIP

Hot glue can be dangerous and should be used with adult supervision.

INSTRUCTIONS

1. Place your foam wreath on a work surface. Lay down a base layer of moss or leaves to cover the foam.

2. Apply glue to the wreath and then stick items onto it. Use more glue than you might think you need for larger or heavier items like sticks, rocks, or crystals.

3. Let the glue dry and harden before picking up your wreath.

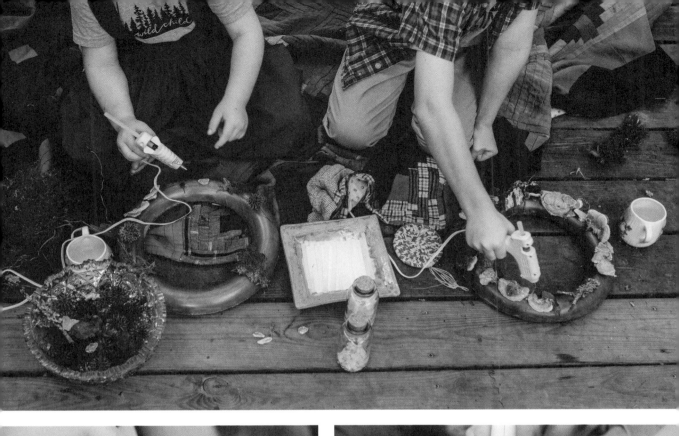

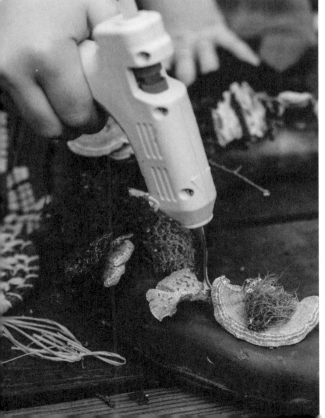

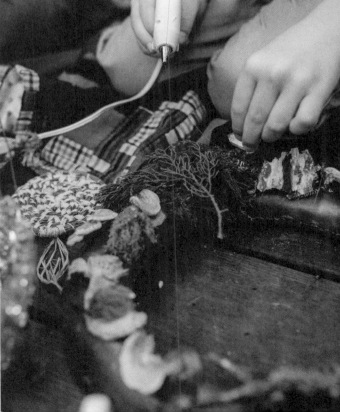

WINTER

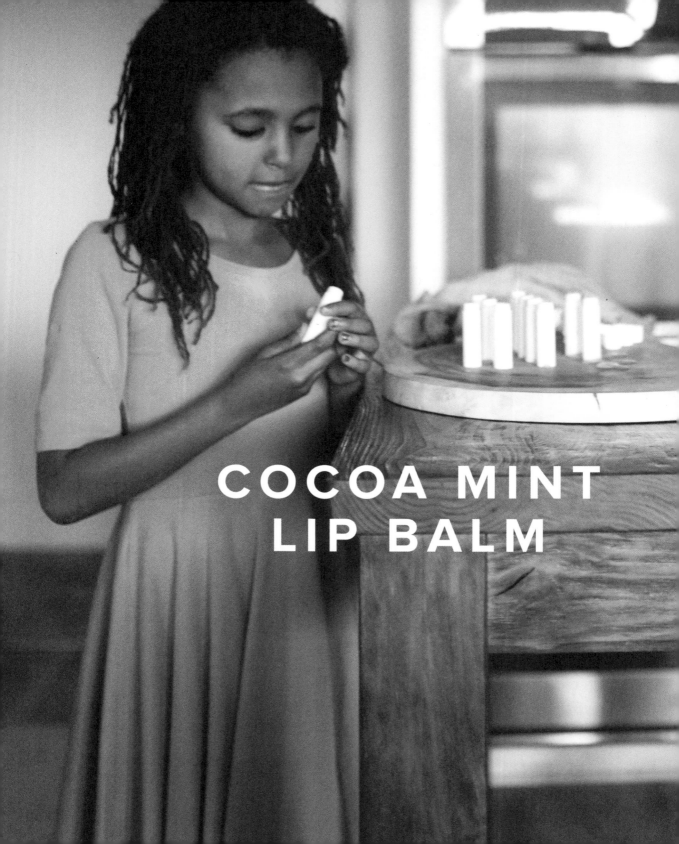

COCOA MINT
LIP BALM

Lip balm is my favorite body care product to make. The process is fast and simple—easy enough for an older child to do independently as long as an adult is supervising. And mamas can rest assured knowing the ingredients going on their little ones' lips are natural and safe.

Studies from the National Institutes of Health show that honeybee products such as beeswax are loaded with healing properties. This is why they have a long history in the folk medicine traditions of cultures around the world. Beeswax combined with decadent ingredients like apricot oil and cocoa butter will moisturize even the most chapped of lips.

I have experimented with many lip balm recipes over the years, and this one is my favorite. It will make ten tubes of lip balm, but I often double it and keep extras in my bag to pass out to friends.

MATERIALS

2 tablespoons apricot oil

1 tablespoon + 1 teaspoon beeswax pastilles or grated beeswax

1 tablespoon coconut oil

1 tablespoon cocoa butter

2-cup heatproof thick glass measuring cup (consider dedicating one to this use, as the wax is difficult to remove)

Small pot

Wax paper or newspaper

Empty lip balm tubes (see page 135 for places to purchase)

Metal utensil (like a spoon or fork)

Optional: 5 drops peppermint essential oil, a few drops vitamin E oil (a recommended preservative; I poke a hole in a vitamin E capsule and squeeze a few drops of oil out of that)

SAFETY TIP

Heating elements and hot wax and oil can be dangerous and should be used with adult supervision.

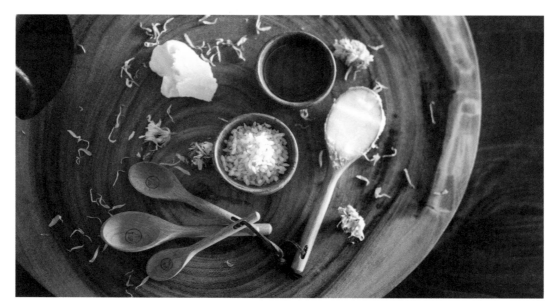

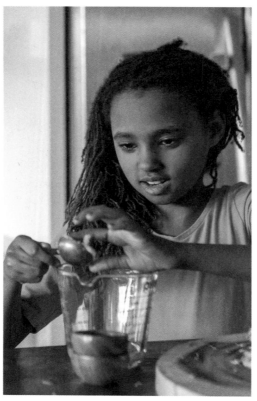

INSTRUCTIONS

1. Combine your oils, the cocoa butter, and the beeswax in the glass measuring cup.

2. Fill the pot about a third of the way with water. Place on a stove over low heat.

3. Gently place the measuring cup in the pot of water, creating a double boiler. Leave the measuring cup handle on the outside of the pot.

4. Allow the beeswax and oils to melt together. This should take only a few minutes.

5. While the mixture melts, prepare your tubes by removing the caps and placing the tubes on wax paper to catch any drips.

6. After the mixture has completely melted together, remove from heat and add peppermint essential oil and vitamin E drops if desired.

7. Give the mixture a stir with a metal utensil. If you wipe the utensil off immediately with a paper towel, it will clean up easily.

8. Immediately pour the mixture into the lip balm tubes.

9. Allow the mixture to cool completely (2 to 6 hours), and then cap your tubes.

10. Test the lip balm on your own lips, then kiss someone you love!

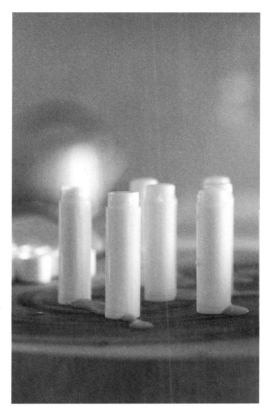

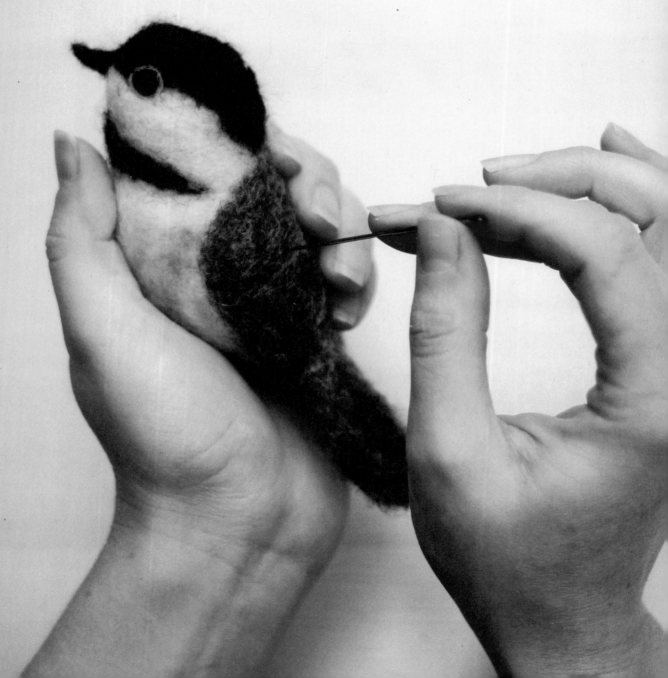

NEEDLE FELTING
CHICKADEES

Needle felting is a wonderful handcraft that my kids and I have come to love doing by the glow of an evening fire or during an afternoon read-aloud. It's especially nice when the winter wind blows against your face and you long to cozy up with those you love.

MATERIALS

Felting needles

Small foam block
(available in most craft stores)

Wool roving in white, gray, black, and light brown

Small skein of light-colored yarn

SAFETY TIP

Felting needles can be dangerous and should be used with adult supervision. Protective finger guards can be found at craft stores.

INSTRUCTIONS

1. Wind 2 small balls of yarn in the shape and size of a small head and a small body.

2. Tear off a piece of white roving (tearing works better than cutting). Place the roving over the balls. Place the ball for the body on top of your foam block and poke it with your felting needle about ¼ inch deep. Be sure to poke straight up and down. Your needle will come out more easily and there will be less chance of poking your fingers.

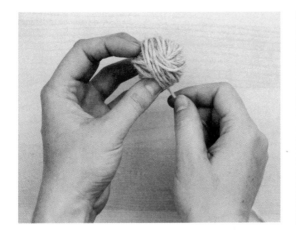

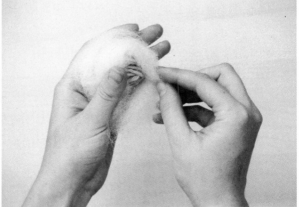

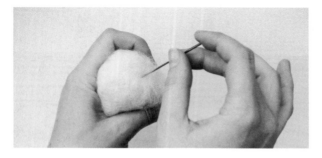

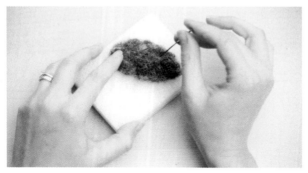

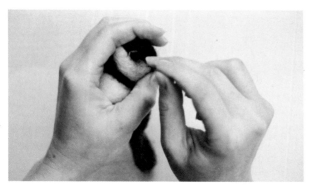

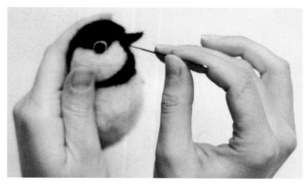

Encourage children to work slowly and carefully. As you poke your ball, the fibers of the roving will begin to felt together. Shape your roving around the ball as you work. Your ball will become firmer, smaller, and less fuzzy.

3. For the head, take the smaller ball and felt some black roving into place on top of the head and under where the beak will be.

4. Working on top of the foam block, take some black roving and shape a beak in the shape of a small cone. Trim with scissors if needed and felt into place on the head.

5. Using a small amount of white roving, form a small ball on each side of the head for an eyeball. Felt in a smaller amount of black roving for the center of the eye.

6. Working on the foam block, felt 3 gray pieces: 2 flat wings and 1 flat tail (they will be slightly different shapes, so don't worry too much about making them consistent). Felt them on with a coat of gray on the bird's back.

7. If desired, felt a very thin, small amount of light brown onto the belly to give the chickadee a realistic touch.

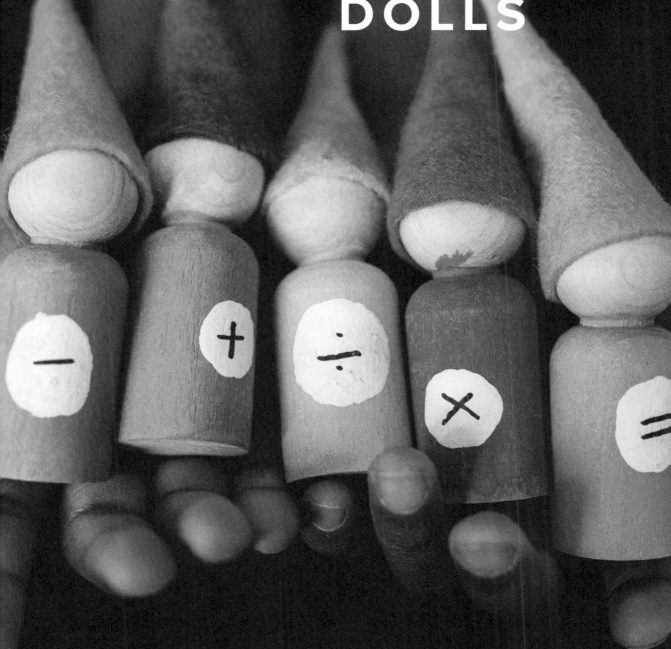

GNOME PEG DOLLS

have always enjoyed creating, but as my family started to grow I became busy with the everyday tasks of taking care of my little ones, which meant pursuing creative outlets took a back seat. As my children grew, however, I saw the magic of their imaginations and was reminded of how creativity is an inherent part of us all. Have you ever noticed that children don't have to be taught how to be creative? We only need to give them the space, tools, and encouragement to nurture their exploration.

I have learned that it is essential for my family to nurture our creativity and to make it a part of our family rhythm. When we make time to create, we feel happier and more fulfilled. Creating as a family has become one of our greatest joys; it connects us in a beautiful way.

Whether your family enjoys cooking, writing, making music, painting, photography, or being out in nature together, by making time in your days to pursue the creative things you enjoy, you will grow together in new ways as a family.

Peg dolls are easy and fun to make and can be used for imaginative play and storytelling. They can even add an element of fun to math or nature studies when made into math gnomes or seasonal gnomes.

MATERIALS

Wooden peg people (available in craft stores or online)

Wool felt

Paint (watercolors or other)

Paintbrushes

Craft glue

Paper (for making patterns)

Scissors

Pencil

INSTRUCTIONS

1. On a work surface, paint a wooden peg as desired.

2. Draw and cut out paper patterns for accessories, such as hats and capes. Hats can be made from a triangle shape. Try the patterns on your wooden peg.

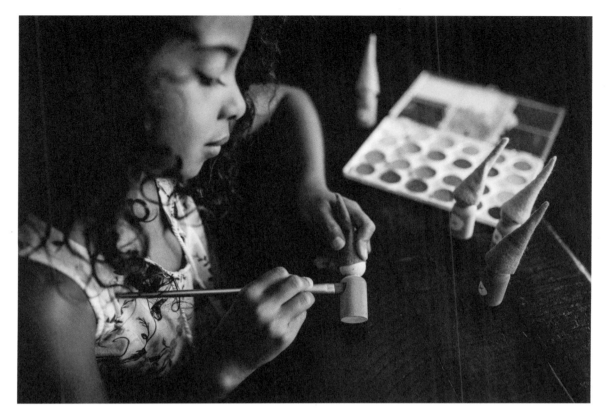

3. When you're happy with the fit of your patterns, use them to cut out clothing from the felt.

4. To make a hat, put glue along one edge of a felt triangle and roll it into a cone. Your cone will be uneven along the bottom; just trim a little to even it out.

5. Glue hat, clothes, and any other accessories onto your gnome.

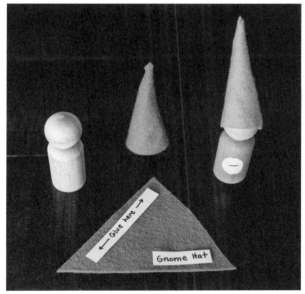

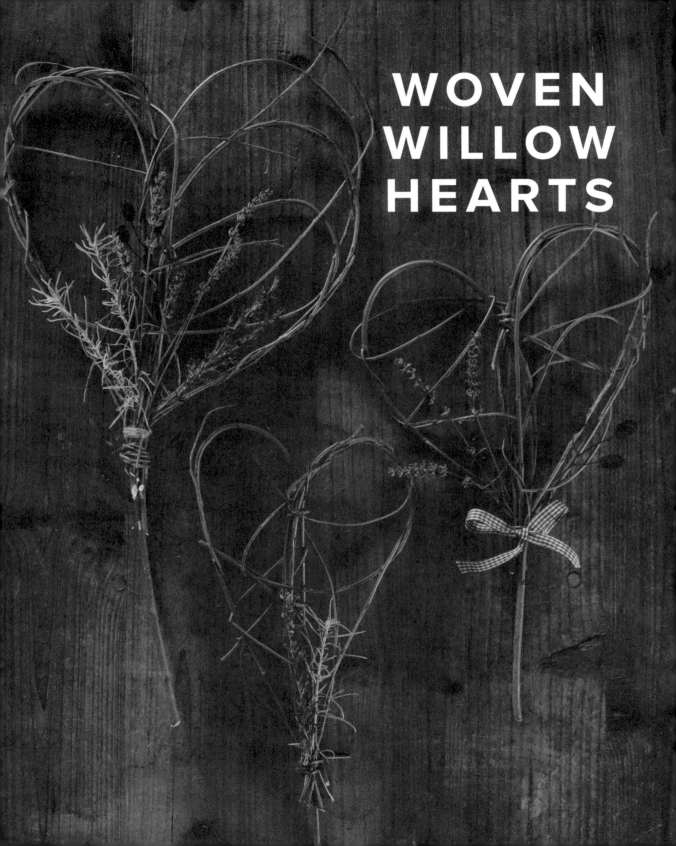

WOVEN WILLOW HEARTS

Ever since I was a little girl, I have been fascinated by the art of basketry—by the memory of the calloused hands I once saw weaving magic with a bunch of sticks at a country fair, by my mother's grocery basket, and by the beautiful crib that has held our family's babies for more than a century.

As I grew older, I came to fully understand the beautiful way in which this age-old craft transforms nature's expressions of strength and growth into objects that can last for generations. I wanted to try willow weaving with my boys, but knew it needed to be a project that wasn't too complicated (or discouraging) for a first attempt. It would need to be something that required no experience in basketmaking and that even younger children could work on independently (though they still might need help to make the necessary knots and ties).

That's when I thought of these willow hearts. My boys had a blast making them, and they look great hung on our wall.

MATERIALS

Willow shoot branches, ideally from first-year growth (you can use either fresh ones or dried ones that have been soaked in water for a few days to make them flexible again; see page 135 for places to purchase)

Sharp scissors

Ornaments and nature treasures for decoration (ribbons, fresh or dried flowers or herbs, pine or alder cones)

Optional: hemp string

Sharp scissors can be dangerous and should be used with adult supervision.

INSTRUCTIONS

1. Choose 2 willow shoot branches of approximately the same size, take them in one hand, and gently bend them over on themselves to create a heart shape.

2. Using a thin, bendable shoot, create a tie around the four twig ends to secure the heart shape. Alternatively, you can use a piece of string to make sure the twigs don't slip out of place.

3. If your structure fans out too much, you can make another tie at the point where the two branches intersect at the top of the heart.

4. Add 2 or more thin, flexible twigs in the free spaces within the ties, or add them on using a twig tie if you have used a string to secure the basic structure. Loosely weave the added branches through and around your initial heart shape to create a web. The ends of your willow shoots can be tucked into the already existing ties or into where two twigs are touching.

5. You can give your willow heart some extra flair by weaving ribbons, fresh or dried flowers or herbs, or small nature treasures such as pine or alder cones through the web created by the willow twigs.

6. Cut away the ends of the branches that you used to create the heart structure. You can leave a single long end if you wish to use your willow heart to decorate a garden or flowerpot.

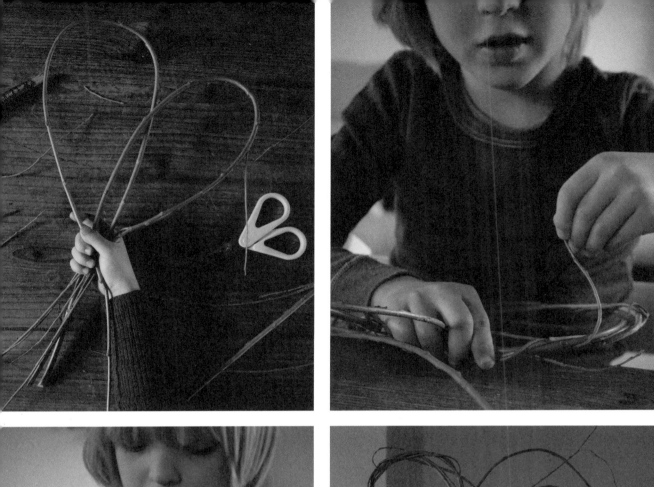

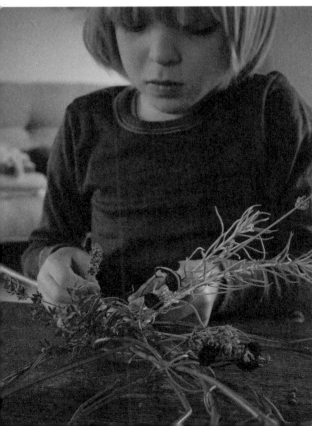

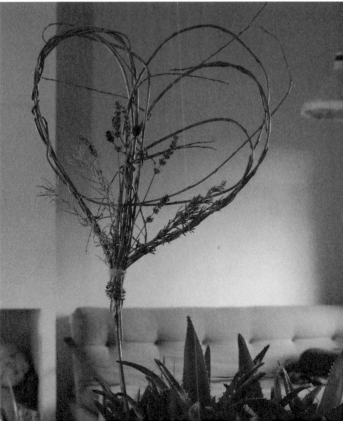

THE STORIED HISTORY OF
HANDCRAFTS IN EDUCATION

BY AINSLEY ARMENT

Handcrafts have defined cultures since the beginning of time. From the carpet weaving of Turkey to the batik of Indonesia, artisans have been working with their hands for thousands of years. In some ancient communities, artistry was a privilege for the wealthy and not accessible to everyone. As someone who educates my children at home, I was curious to learn about how handcrafts have been used in educational efforts over the years.

One of the first nationwide handcraft-based education systems I came across was the slöjd system in Sweden. Slöjd (pronounced *sloyd*) is a system used prominently in Sweden since the 1870s. Students between the ages of nine and fifteen take classes in handcrafts ranging from textiles to wood or metal, as well as paper-folding, sewing, embroidery, knitting, and crochet.

Early proponents of slöjd, including educator and writer Otto Salomon, believed the approach played a critical role in developmental education, as handcrafts "built the character of the child, encouraging moral behavior, greater intelligence, and industriousness." Salomon opened a school for teachers where they learned handcrafts in order to teach the skills to their students. The idea spread, and teachers from all over the world attended.

Today, slöjd is mandatory in Swedish schools. The curriculum focuses on three areas: developing the ability to create and design self-made products, learning to use

various hand tools and materials, and expressing cultural and aesthetic values.

But what about handcrafts in the history of American education? Of course, many children learned handcrafts at home. From sewing and cross-stitching to woodworking and blacksmithing, families were the incubators for life skills and handwork. Think of Laura Ingalls in *On the Banks of Plum Creek*.

But handcrafts weren't prevalent in American compulsory schooling. The focus has been more on the head and less on the heart and hands. Educators like Charlotte Mason, Rudolf Steiner, Loris Malaguzzi, and Maria Montessori began advocating for the place of handwork in education, but it wasn't common in government-funded schools. Then in the early 1890s, Finnish educator Meri Toppelius brought the system of slöjd to America. Quiet and resolved, she pioneered this work in Chicago's Agassiz School despite many battles with the school board. Although she was allowed to teach the children—all boys—only once a week in the basement of the school, she pressed on to adapt her model to her pupils.

An issue of *Kindergarten Magazine* from 1895 shared the story of Toppelius and her work at the Chicago Agassiz School: "The work which they accomplished, the exercise which they gained, the dexterity which they acquired was in unity of concept; the perfection of completion was continually in their eyes and hearts, and they wrought with joyous enthusiasm, through the agency of simple, artistic, and true forms, and by the guidance of their own creative instincts, their whole salvation of body and soul."*

The inclusion of slöjd education died out in American schools in the early 1900s, but with the inspiration of Salomon, Toppelius, Mason, Montessori, Steiner, Malaguzzi, and others, we can reclaim this lost art. Parents were once the slöjd educators, and they still can be today. We can ourselves give our children an education rich in nourishment for the hands, the head, and the heart.

* May Henrietta Horton, "Meri Toppelius—In Memoriam," *Kindergarten Magazine: Monthly Text Book of the New Education* 8 (September 1895 – June 1896): 474.

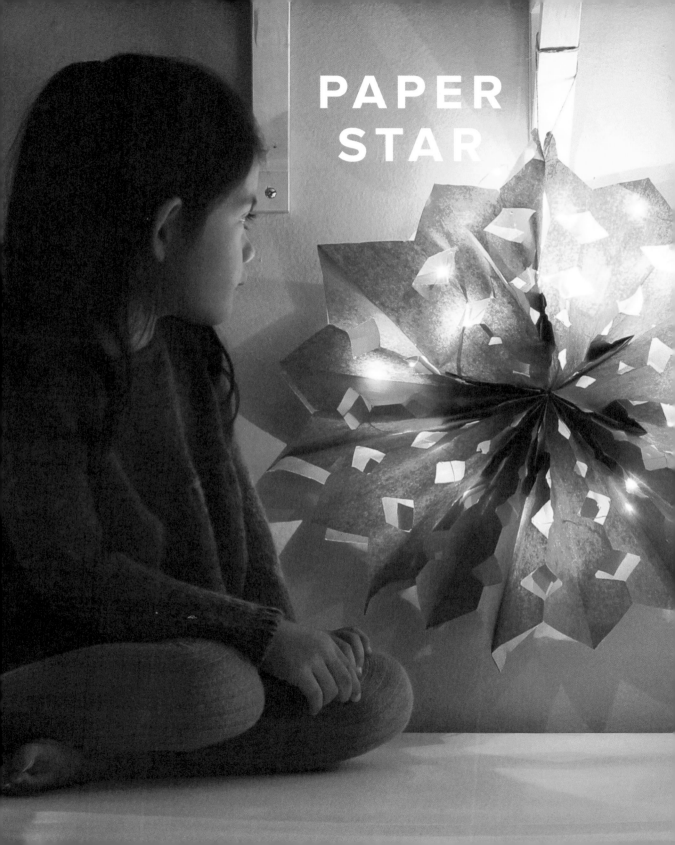

PAPER
STAR

Strings of lights, whether on a trimmed tree or draped over the mantel, are one of my favorite parts of the holiday season. It's magical to have the house illuminated by the soft glow of twinkling lights once night falls.

This paper star is fun and easy to complete, and stringing lights through the star adds a wonderful touch of holiday brightness.

MATERIALS

8 brown paper bags

Hot glue gun

Scissors (strong enough to cut through multiple layers of paper at once)

Twine or ribbon

Strand of battery-operated twinkle lights

Pencil

SAFETY TIP

Hot glue and heavy-duty scissors can be dangerous and should be used with adult supervision.

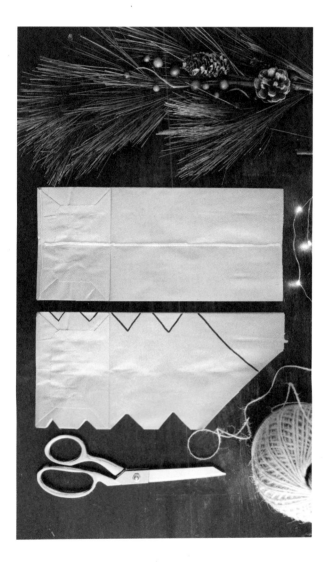

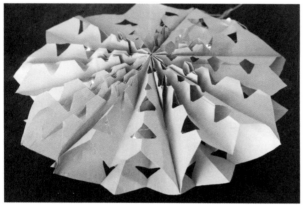

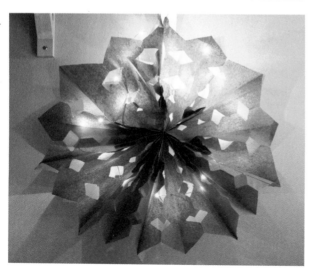

INSTRUCTIONS

1. With a hot glue gun, place a line of glue down the center and across the bottom of one paper bag, forming a T. Place the next bag on top of the glued bag and repeat until all 8 bags are glued together. Be sure the bags are all facing the same direction.

2. With a pencil, mark a design and then cut through all the layers of bags to form the holes and the top part of the star. See the photo on page 51 or look online for design ideas.

3. Use hot glue to attach the twine along the center of the bags, making sure to leave enough length beyond the tip of the star so that it can be hung once completed.

4. Using the point of the scissors, poke a hole in the center of the bags and string the lights through. Open the bags and evenly distribute the lights throughout the star.

5. Pull the two ends of the bags together and use hot glue to connect them. Place the battery packs for the lights inside the top pocket near the two pieces of twine that will be tied together.

6. Hang the star to be admired!

NATURE CARDS

Cheer

Kentucky bluegrass

reed grass

cotton grass

Great Bulrush

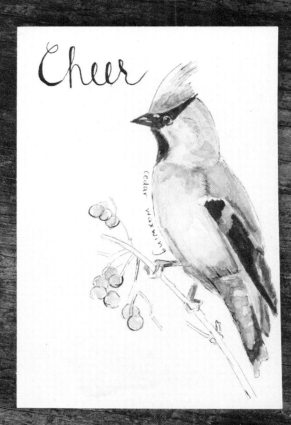

Cheer

cedar waxwing

What better way to surprise your friends and family members than to send them nature cards that you made yourself? The Strathmore® Company makes watercolor postcards that are fabulous to personalize and mail out. One side of these 4 × 6-inch cards is 140-pound watercolor paper, perfect for creating your own watercolor on. On the other side there's space for a personal greeting, address, and stamp.

You can either send out the originals or get them duplicated at a printing shop. If you're sending the cards to rainy regions, you might want to have them printed on water-resistant paper or stick them in envelopes to protect the artwork. Your artists can create whatever they wish to share; I recently painted some cedar waxwings that had caught my imagination.

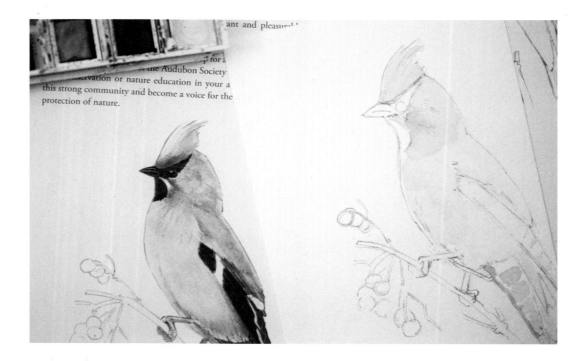

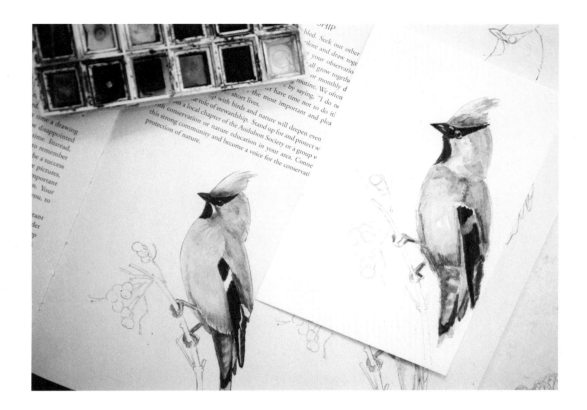

MATERIALS

Watercolor postcard (see page 135 for places to purchase)

Watercolor paints

Paintbrush

Pencil

Ruler

Ultra fine–tip pen (.005 recommended)

INSTRUCTIONS

1. Find an image of a bird (a cedar waxwing, or whatever kind you'd like!) to use as reference. Begin by making a light pencil sketch of the bird's head on the postcard. Use a ruler to get the proportions right if needed. Adjust details until you are satisfied.

2. Using the watercolors and a paintbrush, mix and apply shades of color to the bird, layering them from lightest to darkest.

3. Use the ultra fine–tip pen to add slight lines for definition.

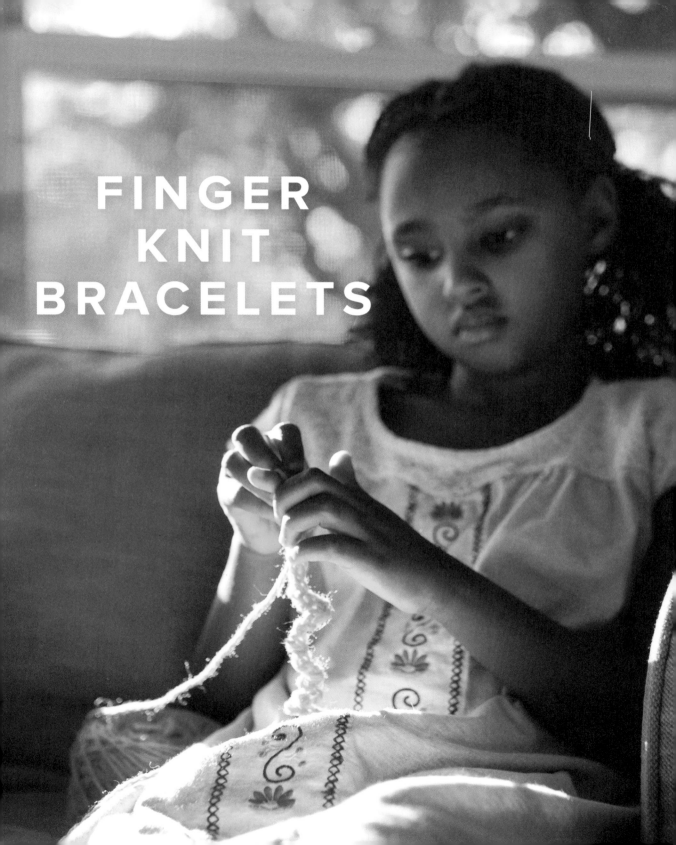

FINGER
KNIT
BRACELETS

Finger knitting is a great activity that results in enhanced dexterity, concentration, and hand-eye coordination for those not yet ready for work with knitting needles. It keeps hands busy during read-alouds and is a good sensory activity for days when you're cooped up inside.

I used leather cording for this project, which I purchased from an independent fabric and yarn shop. For younger children, the leather cording is easier to work with than yarn. Choose whichever is most pleasing or practical for you and your child.

MATERIALS

Yarn or leather cording
Scissors
Optional: beads

INSTRUCTIONS

Making a slip knot is the first step of finger-knitting, needle-knitting, and crochet projects. For this project, you will want to leave a 3-inch tail behind the slip knot.

1. Make a loop with your yarn or cording.

2. Form another loop and push it through the first loop.

3. Pull the loop tight.

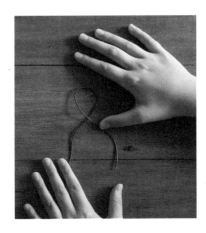
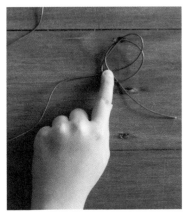
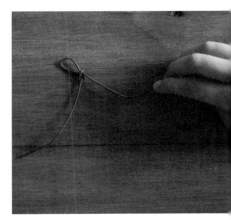

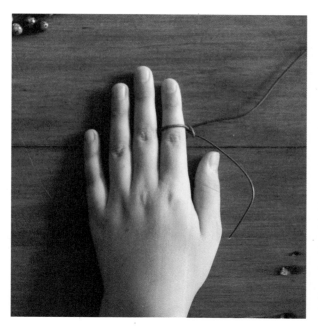

Now you are ready to finger knit.

1. Place the slip knot on the index finger of your nondominant hand.

2. Wrap the yarn around your index finger, forming a second loop above the first.

3. Pull the bottom loop over the top loop.

4. Repeat steps 2 and 3 until you have a chain of stitches of your desired length.

If you want to add beads to your bracelet, you can add one every few stitches. Or you can come up with your own design. You could place beads only in the center of the bracelet or add several beads and then sev-

eral more stitches. It's easy to unravel finger knitting, so don't worry if it doesn't look right the first time. You can always start again.

If you are working with a ball of yarn, you will want to string the beads up onto the ball first before you begin knitting. Then slide each bead down the string when you are ready for it. When your bracelet reaches the desired length, tie a half granny knot at the end of your knitting so it doesn't unravel. (A half granny knot is the first step in tying shoes.)

You will want to leave a 2- to 3-inch tail on each side of the bracelet, so your bracelet will measure the diameter of your wrist plus the two 2- to 3-inch tails on the ends. Knot

the ends of the tails. If you'd like to add beads to the tail, do this first and then knot the tail.

Finally, make an adjustable closure. This will allow you to take the bracelet on and off, as well as loosen it or cinch it tighter so it fits your wrist perfectly.

1. Place the two tails so that they run parallel to each other with the top tail pointing left and the bottom tail pointing right.

2. Cut a piece of yarn 8 to 10 inches long. This will become the tie yarn. In the center of the two tails, tie a half granny knot with the yarn. Pull the knot tight.

3. Rotate the bracelet 90 degrees to the right. Take the bottom tie yarn and wrap it under both bracelet tails and over to form a loop. Pull tightly to form a knot.

4. Now take the top tie yarn and place it over the two tails and then under to form a loop. Again, pull tightly to form a knot.

5. Tie a final half granny knot with the two yarn tie ends. Pull snugly so the knot is tight.

6. Clip off the tails at the knot.

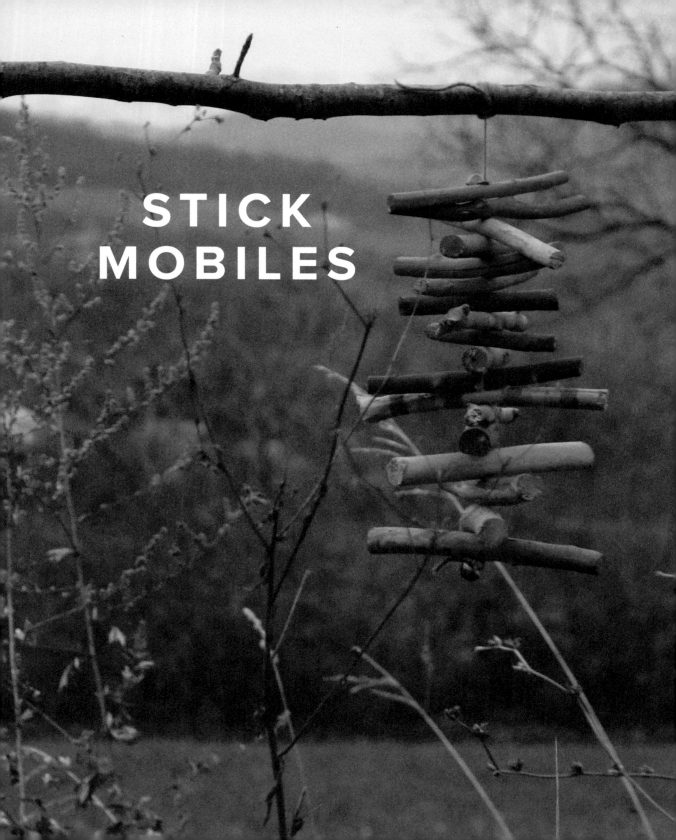

STICK
MOBILES

January is a month when winter can suddenly seem bleaker and less romantic. With the busy bustle of the holidays past, the rest of the season lies before us, dark, cold, and quiet.

No matter how much I enjoy the coziness of those long winter evenings with candles burning and a fire crackling in the kitchen stove, some days the grayness of the bare, windswept land makes me long for lighter days and the arrival of spring.

These are days when I have to remind myself that January is also a month of new beginnings, a month that invites us to re-evaluate and perhaps rearrange some of our family rhythms and allows us to set some new goals and intentions for our home-schooling journey.

These stick mobiles make use of the austere resources offered by winter and yet remind us of new possibilities that are brought by the turn of a new year.

MATERIALS

Clean, dry sticks (we have a lot of pine trees nearby, so we chose to work with pine sticks that had already lost their bark, but you can use any sticks that have smooth bark, such as American beech, ash, or driftwood)

Small saw

Hand drill

Paint

Paintbrushes

Yarn or string

Bells, beads, or ribbons to embellish the mobile

Optional: tapestry needle, power drill

SAFETY TIP

Saws and drills can be dangerous and should be used with adult supervision.

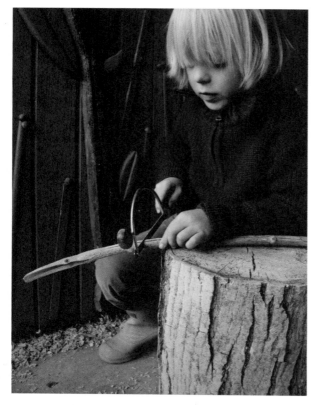

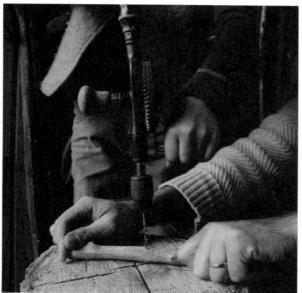

INSTRUCTIONS

1. Gather branches and cut them into small sticks of different lengths.

2. Using the hand drill, make holes in the sticks wide enough to pass a piece of yarn or a tapestry needle through.

Note: If you're working with younger children, you or an older child can complete this step for them. We started out using an old-fashioned hand drill, which usually works like a charm. But in this case we needed quite a lot of holes drilled, so we defaulted to a power drill.

3. Paint the sticks, adding any desired details, such as dots or stripes.

4. Once the paint is completely dry, tie a small bell to the end of a piece of string and thread it through the sticks to create your mobile.

5. Embellish with bells, ribbons, or nature treasures.

6. Find a tree that would welcome some happy colors to fight those winter blues!

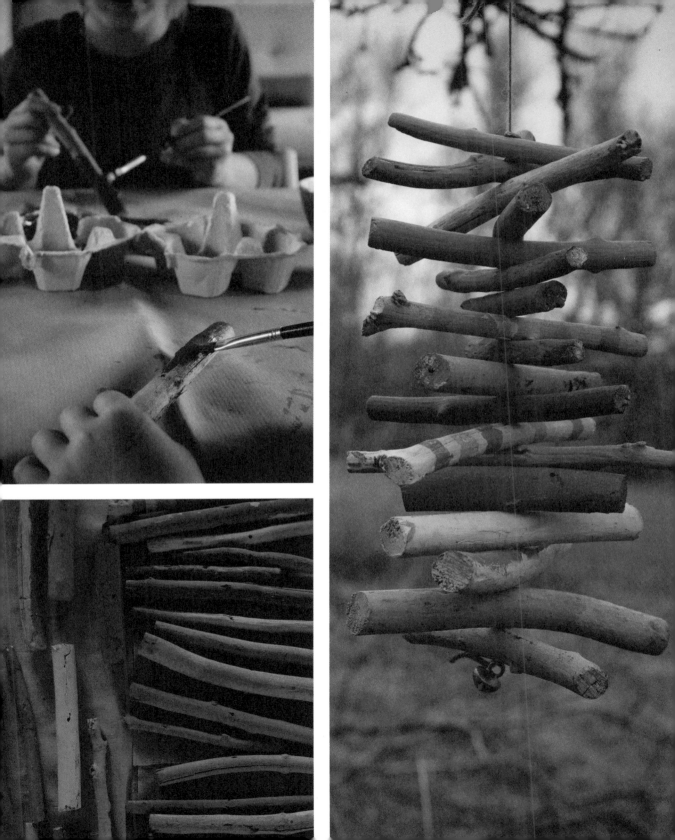

SPRING

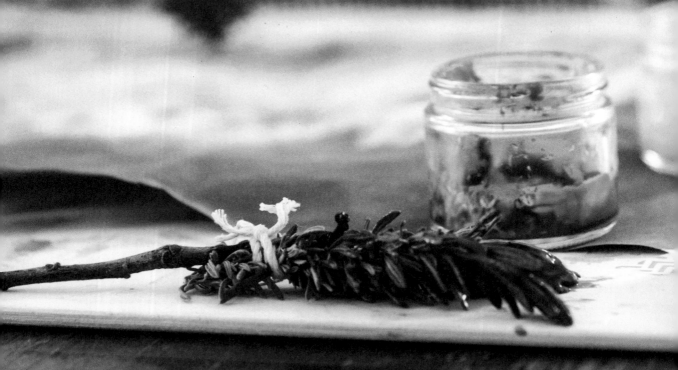

NATURE PAINTBRUSHES

Art has been a part of my identity since I was a little girl. When I was seven years old, a neighbor girl who was a few years older sketched a simple portrait for me. It was thrilling to see how a few lines of pencil on paper could form something so delightful. I copied that portrait and the other figure drawings she had shown me. I later took art classes and loaded my sketchbook with art, filled with joy and growing in self-esteem.

One day I found myself with a seven-year-old of my own seized with her own need to create. She began asking for paper, colored pencils, clay, beads, tape, string, and, of course, paint! This need resonated with the artist in me, and I wanted to say, "Yes!" But as the grown-up in charge of sweeping floors and rinsing paintbrushes, I would instead hear myself say with a sigh, "Another day," or "How about a movie?"

I wanted our home to be a place of creativity and inspiration for my children. That meant stepping out of my comfort zone and welcoming some mess into our space.

Last year, I decided to start saying yes to paint. Sometimes that would mean dropping everything to get out paint and paper; other times it meant intentionally scheduling an art session later in the week.

I rearranged the paint supplies for easy access, got long-sleeved smocks for everyone, and found some good washable paints. We didn't do it daily or even weekly, but our smocks and watercolor boards bear the marks of young artists, while our dining room table has become our family art studio.

As we have made time for painting, I have found a lot of satisfaction in combining art and nature. The beauty of natural colors and forms is both inspiring and therapeutic. One way to bring some nature and sensory fun into your painting sessions is by making your own paintbrushes. These paintbrushes can be used over and over or discarded for easy cleanup. We did our painting at our dining room table "studio," but this would also make a great outdoor activity for a group.

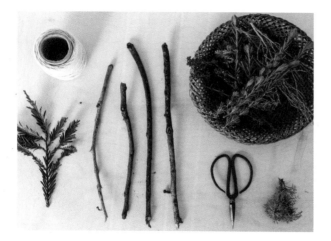

MATERIALS

String or rubber bands

Scissors

Bits of trees, grasses, or other plants for bristles

5 to 7 twigs for handles

Paint (I like washable tempura for this activity)

Paper

INSTRUCTIONS

1. Gather a variety of twigs, leaves, grasses, and other plants from outside. You can find what you need for this project at the park, your favorite nature spot, or even in your backyard. Evergreens such as redwood make nice sturdy brushes. We used herbs from our garden, which created nicely sized brushes of different textures.

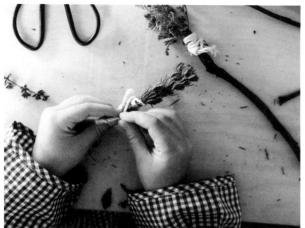

2. Break twigs down into paintbrush-handle sizes.

3. Attach plants to the ends of the twigs using string or rubber bands.

4. Enjoy painting with the variety of brushes you have created.

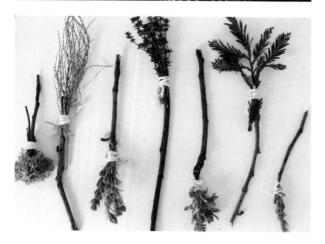

EGG TEMPERA PAINT

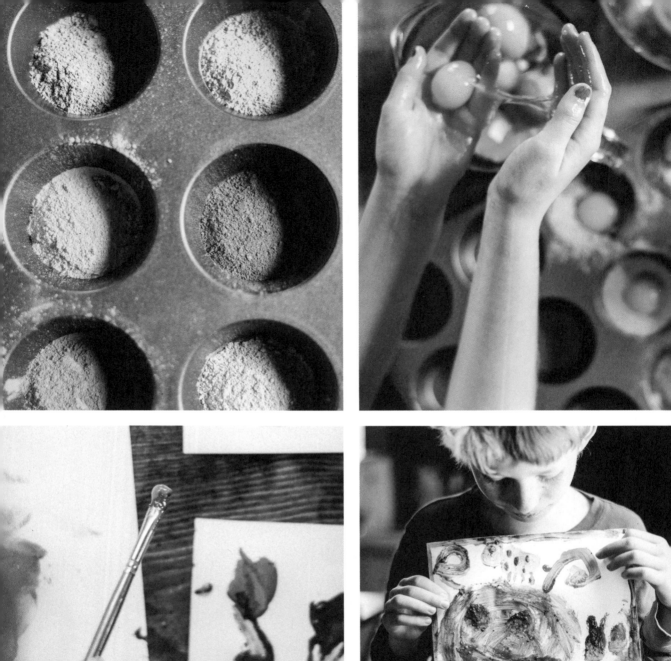

Egg tempera paint was wildly popular both before and during the Renaissance. Artists such as Botticelli, Giotto, Fra Angelico, and Leonardo da Vinci used this medium before oil paint was introduced. Pigments from rock, wood, bone, insects, plants, or soil would be mixed with water and then tempered with egg. This ancient technique produces a water-soluble paint that dries quickly and creates vibrant, beautiful colors.

MATERIALS

Nontoxic colored chalk

Old coffee grinder, mortar and pestle, or reclosable plastic bag and hammer or rock

Small bowls or muffin tin

6 to 8 egg yolks (albumen, the protein found in egg white, prevents paint from adhering well, so make sure to use only the yolk)

Water

Paintbrush

Paint paper or canvas

 SAFETY TIP

Ingesting raw egg can result in illness, especially in young children.

INSTRUCTIONS

1. Separate the chalk by color and grind it up using an old coffee grinder or mortar and pestle, or put the chalk in a reclosable plastic bag and have the kids smash it with a rock or hammer. The finer the powder, the better. If you don't have any old chalk, you can use food coloring or spices or other powders like activated charcoal for black, turmeric for orange, ground parsley for green, and ground mustard for yellow.

2. Experiment to see what colors you can create. Place each pigment, or color, in a separate bowl or section of a muffin pan.

3. Add egg yolks directly to the pigments—1 per bowl or compartment—or mix each yolk with about ½ teaspoon water first to lengthen the paint (I recommend this if you have multiple kids painting).

4. Mix yolk and pigment until blended, then have fun creating beautiful masterpieces! This paint works well on paper and canvas. As the tempered pigment sits, the yolk becomes thicker and more difficult to paint with. The water also evaporates, so don't try to store this paint for future use.

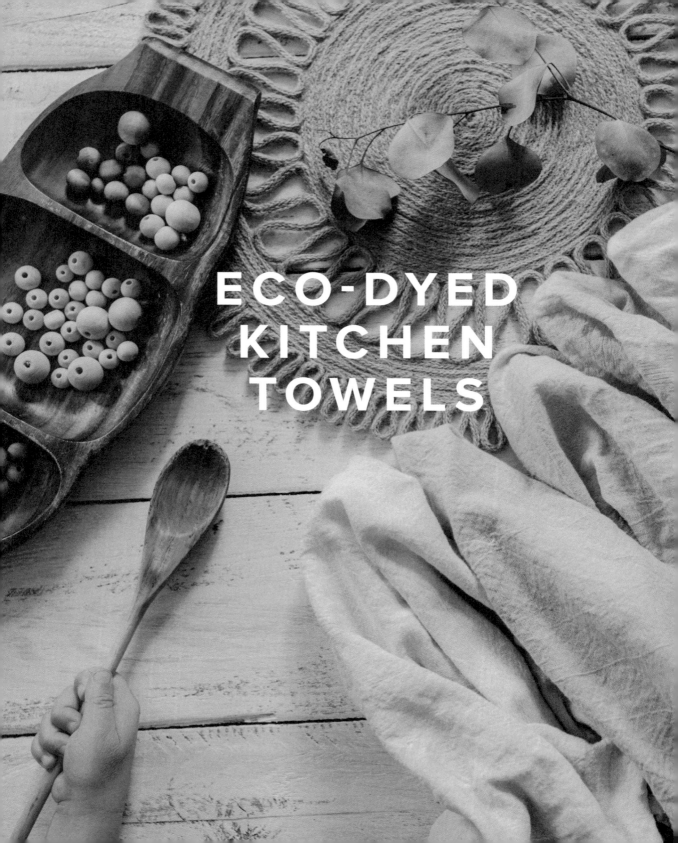

ECO-DYED KITCHEN TOWELS

Ours is a home that brims with color. The dining room walls are apricot, the halls are lined with watercolor paintings from little hands, and the windows are crowded with rainbow kite-paper stars. Before I had children, I dreamed of this sort of home.

When I first became a mother and then later chose to homeschool, my artist's soul rejoiced to find that education could be not only a delicious feast, as Charlotte Mason described it, but also a feast infused with a palette of color and beauty that describes the vibrancy of our family. Math could be served with a sweet musical glaze, history could be drizzled with a rich gravy of poems, and art could be the bright zest we sprinkled through the bubbling stews of chemistry.

As often as I can, I try to use my natural appetite for art, creativity, and nature to bring an extra avenue of sensory exploration to our kids' learning. For this activity, my boys and I embarked on an investigation of natural dye methods, using simple items from around the kitchen. This organically led to a discussion about mordants, the pH scale, food waste and composting, and the science of color and how it is perceived by the human brain.

We have been experimenting with eco dyes for a few years and are always enchanted by the miraculous process of unfolding color. One of the loveliest things about the process is how each result can be as unique and surprising as the curious little hands and minds that created it.

MATERIALS

**White cotton
flour-sack towels**

Large pot

Water

White vinegar*

Baking soda*

Salt*

continued

** These ingredients are food-safe mordants for natural dyes that help the dye adhere to the fabric. Some plants contain natural tannins that eliminate the need for additional fixatives. If you are feeling adventurous or have older children who can safely handle these substances, try researching and experimenting with pretreating your fabric with alum, iron, copper, or washing soda as alternative mordants.*

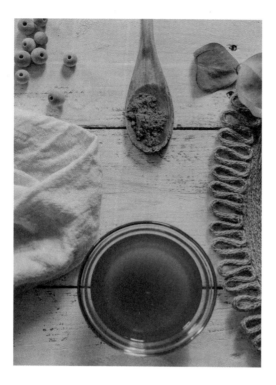

Stirring spoon (one you don't mind getting stained)

Turmeric

Rooibos tea (bags or loose-leaf; can also use other dark teas or even coffee)

Red cabbage

5 or 6 avocado pits (fresh or frozen; thoroughly cleaned)

Hibiscus tea (bags or loose-leaf)

Optional: wooden beads or other natural-fiber materials such as wool yarn to dye, coconut oil

 SAFETY TIP

Stoves and hot water can be dangerous and should be used with adult supervision.

INSTRUCTIONS

YELLOW (TURMERIC)

1. Fill your pot with about 6 cups of water. There should be enough water to fully submerge your towels.

2. Stir in 1 teaspoon of turmeric (more if you desire a bolder color) and a splash of vinegar.

3. Wet a towel by rinsing it thoroughly under water. Then submerge it in the dye pot.

4. Simmer/steam the mixture on very low heat for about 10 minutes.

5. Allow the mixture to cool completely before removing the cloth and rinsing it under cold water until the excess dye is washed out and the water runs clear.

6. Allow the towel to air-dry or run it through a dryer cycle on low heat.

BEIGE (ROOIBOS TEA)

1. Fill your pot with about 6 cups of water. There should be enough water to fully submerge your towels.

the excess dye is washed out and the water runs clear.

7. Allow the towel to air-dry or run it through a dryer cycle on low heat.

(Try experimenting with coffee or other dark teas for various shades of brown. Many other teas will produce a lovely beige—rooibos was just what we had in our cupboard.)

BLUE (RED CABBAGE)

1. Fill your pot with about 6 cups of water. There should be enough water to fully submerge your towels.

2. Roughly chop the cabbage and add it to the pot.

3. Bring the mixture to a simmer on low to medium heat. Simmer, stirring occasionally, for about 30 minutes until the rich blue color has leached into the water.

4. Strain out the cabbage pieces. Discard.

5. Add 2 tablespoons of salt.

6. Wet a towel by rinsing it thoroughly under water. Then submerge it in the dye pot.

2. Add 3 or more rooibos tea bags or a few tablespoons of loose-leaf rooibos, along with a splash of vinegar.

3. Simmer/steam the mixture on low heat for about 15 minutes.

4. Wet a towel by rinsing it thoroughly under water.

5. Strain out the tea bags or leaves from the pot before adding the towel.

6. Allow the towel to steep in the dye for a few hours (no need to simmer it). Remove the cloth and rinse it under cold water until

7. Simmer/steam the mixture on very low heat for about 30 minutes, stirring often.

8. Allow the mixture to cool completely before removing the cloth and rinsing it under cold water until the excess dye is washed out and the water runs clear.

(We left ours in the pot for up to 3 hours because cabbage dye tends to have a harder time adhering to the material. Don't be alarmed if much of the dye runs out of the fabric when you rinse it; you should still be left with a beautiful pale blue.)

9. Allow the towel to air-dry or run it through a dryer cycle on low heat.

(Since red cabbage is also a pH indicator, it can be an interesting experiment to separate the leftover blue dye into 2 glass containers. Add vinegar [acid] to one, which will turn it a lovely pink, and baking soda [alkali] to the other, which will change it to a vibrant turquoise green.)

ROSE (AVOCADO PITS)

1. Fill your pot with about 6 cups of water. There should be enough water to fully submerge your towels.

2. Add 5 or 6 avocado pits.

3. Simmer the pits for about 30 minutes, stirring occasionally. Strain out all pieces of the pits and add 1 tablespoon baking soda. (Avocado pits produce a wide and often unpredictable variety of dye colors, ranging from peach to brown to pink to rose. I have found that adding baking soda can help the color "pink up.")

4. Wet a towel by rinsing it thoroughly under water. Then submerge it in the dye pot.

5. Simmer/steam the mixture on low heat for about 30 minutes, stirring often.

6. Allow the mixture to cool completely and soak for a few hours before removing the cloth and rinsing it under cold water until the excess dye is washed out and the water runs clear.

7. Allow the towel to air-dry or run it through a dryer cycle on low heat.

LAVENDER (HIBISCUS TEA)

1. Fill your pot with about 6 cups of water. There should be enough water to fully submerge your towels.

2. Add 3 or more hibiscus tea bags or a few tablespoons of loose-leaf hibiscus tea, along with a splash of vinegar.

3. Simmer/steam the mixture on very low heat for about 15 minutes.

4. Wet a towel by rinsing it thoroughly under water.

5. Strain out the tea bags or leaves from the pot before adding the towel.

6. Allow the towel to steep in the dye for a few hours (no need to simmer it). Remove the cloth and rinse it under cold water until the excess dye is washed out and the water runs clear.

7. Allow the towel to air-dry or run it through a dryer cycle on low heat.

LEFTOVER DYE: We reused our leftover dyes by soaking unfinished wooden beads in the colors. We simply left them to soak overnight and removed them in the morning, leaving them to dry on paper towels. Once the beads were thoroughly dried, we rubbed them with a bit of coconut oil on a soft cloth to help preserve the colors and the integrity of the wood.

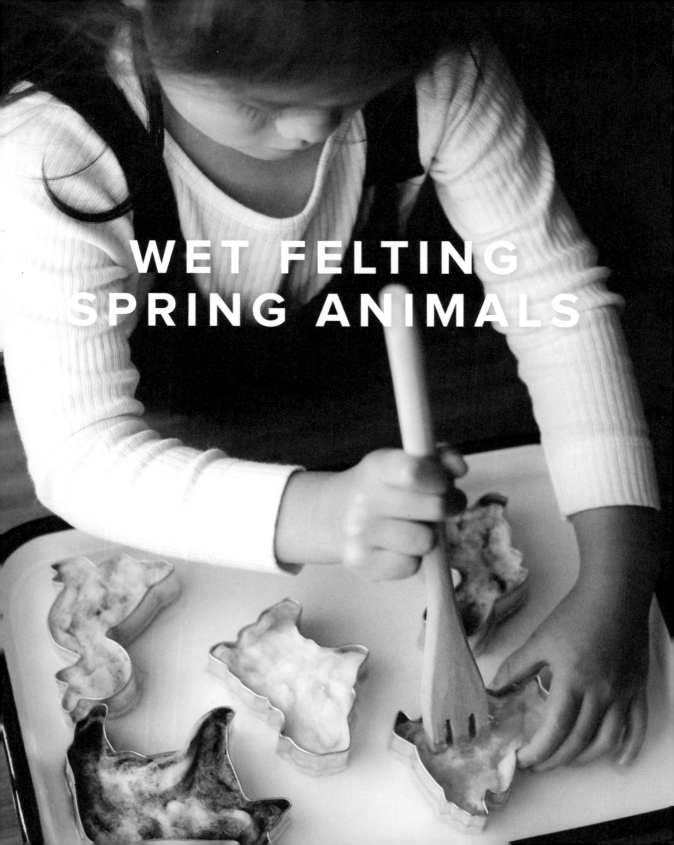

WET FELTING
SPRING ANIMALS

Wet felting has quickly become one of the favorite handcrafts in my home. This felting method is wonderful for little ones as young as three years old, as it promotes fine-motor skills and tactile learning and doesn't require sharp felting needles. Young kids will have the most fun pressing their tiny fingers into the wool-filled cookie cutters. The wet, soapy wool and the way it feels as it tightens beneath their fingers is a sensory delight. Plus, it's so much fun to get our hands wet and soapy and watch our tiny felt creations come to life!

MATERIALS

Wool roving

Spring animal cookie cutters, like rabbits, deer, foxes, or birds; have fun with different cutters for different seasons of the year

Warm soapy water

Warm water (no soap)

Fork

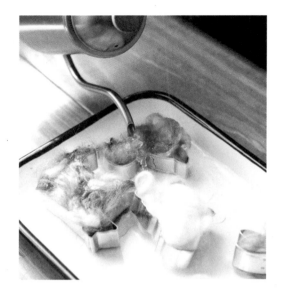

INSTRUCTIONS

1. Choose a project that fits the season—in this case, spring animals—and select cookie cutters and colored wool roving to match.

2. Pull the roving into small, stretched-apart strips and begin filling the cookie cutters with it. The more wool you put in a cookie cutter (even if it overflows), the tighter and stronger your finished product will be.

3. Pour warm water (without soap) to dampen the wool. Push the wool down so all of it fits inside the cookie cutters.

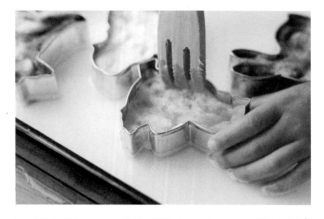

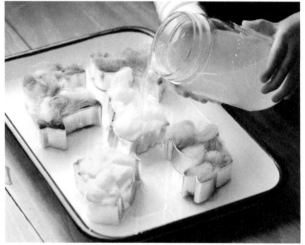

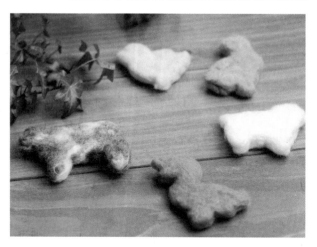

4. Pour warm soapy water into the cookie cutters and begin compressing the wool with your fingers. The soapy water helps tighten the fibers together and speeds up the felting process.

5. Once the wool tightens a bit, switch to the fork and felt for 7 to 10 minutes on each side. You can listen to an audiobook or music or chat to help pass the time.

6. After you have your desired shape and thickness, pop the felts out of the cookie cutters, squeeze out all the excess water, and leave them to dry overnight.

7. Once the felts are dry, you can add needle-felted embellishments, string them together in a garland, turn them into ornaments, or drop some essential oil on them and use them as diffusers.

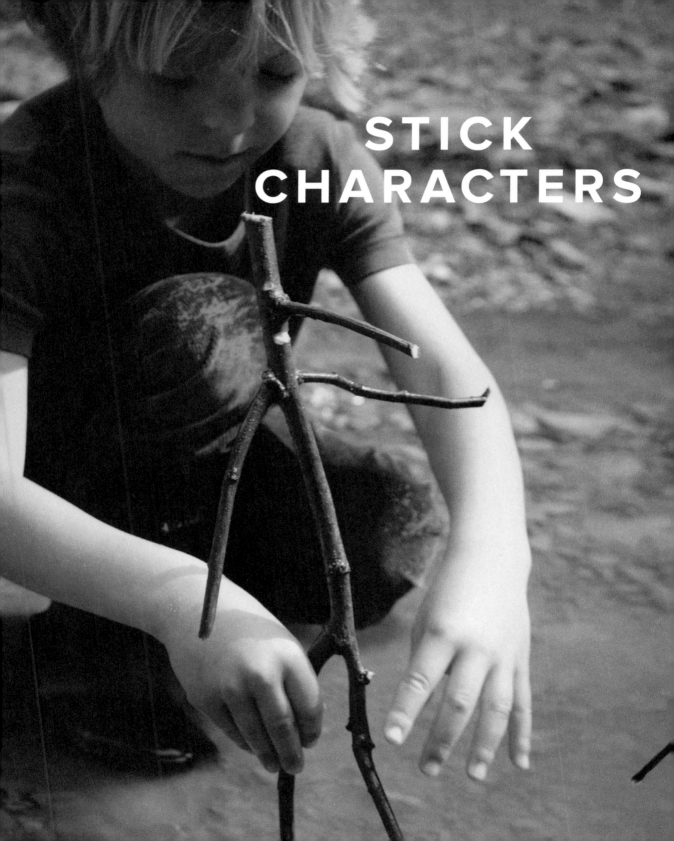

STICK CHARACTERS

There is something magical about the outdoors. Maybe it's the open spaces, the wild abundance of life, or the slow-moving pace of nature itself that makes us exhale and open our hearts to a slower pace and the pleasure of simple things. Or could it be the potential for growth that draws us in, gently pushing us to direct our gaze and choose our path from among an endless array of possibilities? Perhaps it is all of these things, in different measures for each of us, that make the outdoors a place where we come to rest, and play, and grow, and find the stillness we need in order to be truly present for each other.

By living in close contact with nature, getting lost deep in the woods, I've seen how things cross our paths and stories unfold along our way. These stories are told and retold and ultimately find their way back into our children's games. In my family, we often create wooden characters from these stories for my kids to play with. They're nothing fancy or elaborate, but these whimsical creations are always treasured.

This fun and fairly simple craft lets even smaller family members be involved.

MATERIALS

Sticks or small branches

Small saw or gardening shears for cutting and trimming branches

Small carving knife (always to be used with safety gloves)

Hand drill

Optional: pencil or permanent pen for drawing faces, leftover yarn or scrap fabric for clothing

 SAFETY TIP

Saws, shears, knives, and drills can be dangerous and should be used with adult supervision. Safety gloves should be worn when carving.

INSTRUCTIONS

1. Look for branches that could have a character hidden inside of them—sticks that branch out in interesting ways or have remarkable signs or knots on them. Can you find legs? Jaws? Even a tail?

2. Try to imagine what could be done to make that character emerge. Does it need

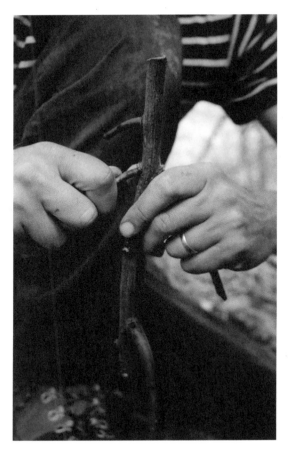
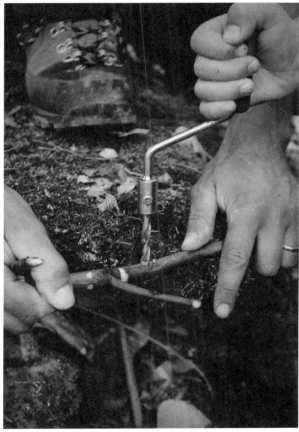

to be trimmed? Sometimes all you need to do is to turn a stick upside down or shorten a few branches to create a little figure with arms and legs. Or is there something missing that could be added? A limb perhaps? You can drill a hole in the body and cut a little stick to size to insert into the hole.

3. Faces can easily be created by carving away a few small slivers of bark to reveal the lighter wood underneath, or you can peel away some of the bark with a carving knife and simply draw the faces on using a pencil or permanent pen.

4. Add small details such as a yarn scarf or some pine-cone hats or maple-seed wings to embellish your stick people—the possibilities are truly endless!

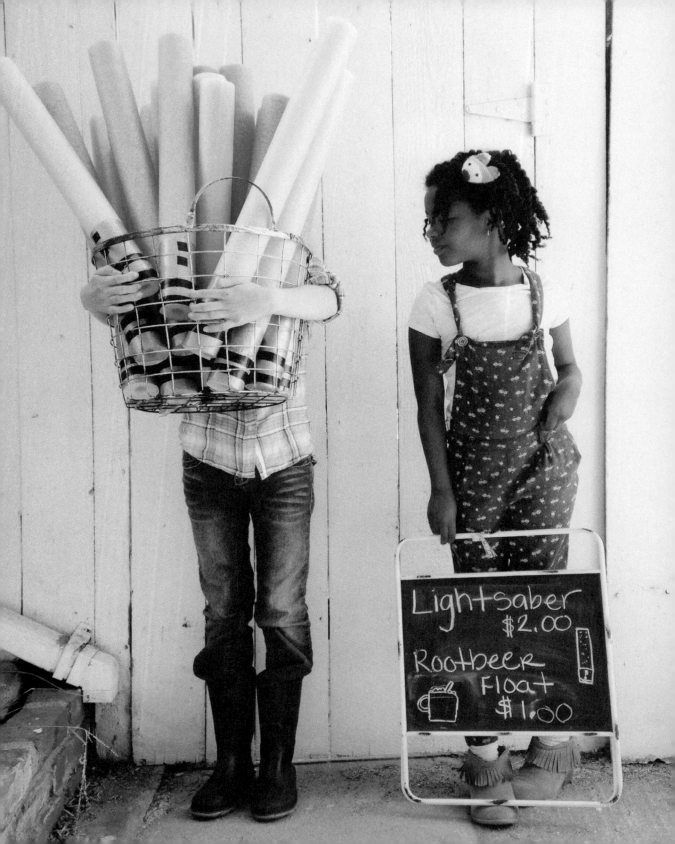

HANDCRAFT FAIRS

BY JENNIFER NARAKI

When our children are actively engaged in handcrafts, there are a number of benefits. Handcrafts awaken their creativity. They lift children's motor activity to the realm of skill. They transform willpower into beauty of form. And they change what would otherwise be an insignificant activity into a virtue. Cultivating these life skills will serve our children throughout their lives.

As valuable as handcrafts are, it can be difficult to regularly implement them. Enter our biannual handcraft fair. Twice a year, our homeschool community gathers at a local nature park. In the months leading up to the fair, anticipation and excitement fill the air as little hands labor busily, tending to their work. At the fair, child artisans proudly display their creations at their booths, eager to sell their goods and excited to see what other crafters have brought.

Organizing your own fair can bring this inspiration and delight to your children and community too.

HOW TO HOST A HANDCRAFT FAIR

1. Make a Plan

Connect with a local group and propose the idea. It could be a nature study group, a homeschool group, a co-op, a religious group, or just neighborhood friends.

2. Choose a Date and Time

Our handcraft fair is always the first Thursday of December and the first Thursday of May. Having consistent, seasonal dates means we can all plan accordingly and encourages a variety of crafts. Some people

work on their crafts all year long, while others work best in the days leading up to the fair. Children often sell their wares and shop at the other booths for a few hours and then are off to play with their newly acquired goods.

3. Set a Location

Our handcraft fair is located in the same place each year—a large park with many benefits, including a nearby parking lot to haul loads in from, a cement stage to set up booths on, and lots of nature to play in after the fair is over. As the fair has grown over the years, the booths have gotten more and more elaborate. Now we have been asked to obtain a permit to use the space. Check with your location about regulations and permits.

4. Choose a Craft

Work with your children to decide what to make. Consider the cost of materials, age-appropriate skills, production time, and so on. You can browse crafting books (like this one!), magazines, and online sources for ideas.

5. Prepare Your Artisan

Obtain materials for your handcrafts. They could be as simple as ingredients in your kitchen or as fancy as jewelry-making and leather-tooling supplies. Prepare your arti-san for a process of trial and error—some glues work with some materials and not others, some glitters clump together while others don't, etc.

Make your creations. Choose how to display them. Decide how much to sell them for. Choose what to name your business. Make a sign for and decorate your booth. This could be as simple as throwing down a quilt on the ground or as elaborate as toting tables, tablecloths, wooden crates, and chalkboard signs to the location. Prepare your cashbox and get ready to sell.

Help your artisan consider how long each step will take and when they want to begin working in order to be ready when fair day arrives.

6. Enjoy the Fair

Prior to the fair, discuss fair etiquette: Encourage other artisans. Don't touch other artisans' creations unless they say it's okay or a purchase is being made. Be polite running your booth. Know how to make change. Arrive at the location with plenty of time to set up your booth before the fair begins. Document the day with photos. Sell your goods. Go visit the other booths and buy goods from other artisans. Have fun!

IDEAS FOR HANDCRAFT WARES

Here are some wares we have enjoyed making for handcraft fairs:

Leather bookmarks

Macramé key chains

Driftwood sailboats

Flower crowns

Necklaces

Drawings

Embroidery

Potted plants

Felted wool

Papier-mâché hot-air balloons

Holiday ornaments

Leather notebooks

Bracelets

Wreaths

Wooden decorative stars

Wooden catapults

Wooden swords

Wooden guns

Robot masks

Miniature wooden houses

Newspaper hats

Animal ears

Acorn teacups and teapot sets

Painted rocks

Magnets

Note cards

Candles

Weavings

Wooden shields

Bow and arrow sets

Pressed leaves

Found-art creations

We've also found edible creations to be a great way to use our hands and provide people with some yummy treats. These can include:

Freshly spun cotton candy

Crisped rice treats

Cookies

Fresh baguettes

Banana bread

Elote (Mexican street corn)

Hot cocoa

Lemonade

Horchata

Granola

Edible-flower lollipops

Fresh herbs from the garden

Taquitos

Salsa

Guacamole

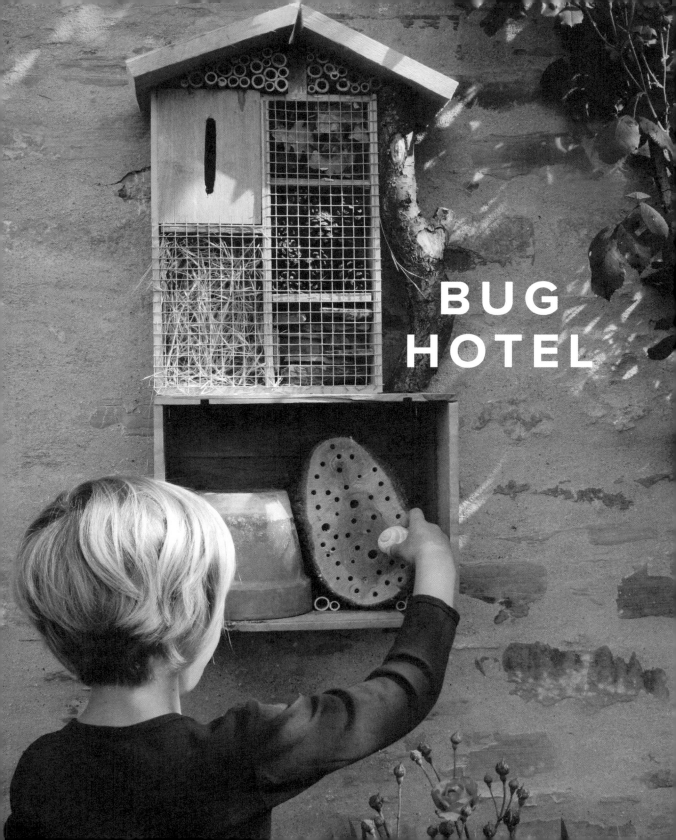

BUG
HOTEL

Did you know that some species of orchids are pollinated by mosquitoes? Or that ladybugs feed on aphids? One of the things I hope to teach my children is a deep understanding of how all creatures, great and small, have their own place and importance in the world. No matter how tiny, scary, ugly, or annoying they may seem, they each have their role to play in the intricate networks of relations that make up our amazing ecosystems.

Without pollinators there would be no apples, no pears, no grapes, no squash, no almonds, no vanilla—the list goes on and on. In fact, it is estimated that more than 90 percent of all flowering plant species rely on pollinators for survival. That means honeybees, bumblebees, solitary bees (bees that don't live in a colony), and butterflies, as well as wasps, moths, and even ants.

My kids and I decided to build a special place to welcome these very important helpers, a place where they can live, hide, hibernate, and even nest. A bug hotel!

MATERIALS

Old crates, drawers, or a small cabinet or cupboard

Hammer

Small saw

Fret saw

Hand drill

Screwdriver or power drill

Staple gun

Small carpentry nails

Screws

Sandpaper

Nontoxic wood glue

Fine-mesh chicken wire

Wire cutters

Pencil

Scrap wood planks or pieces of plywood

Small terra-cotta flowerpot with a hole in the bottom

Wooden log or tree stump

Natural materials such as twigs, stones, dry leaves, straw or hay, pine cones, bamboo or reeds, or empty snail shells

Optional: protective roofing material

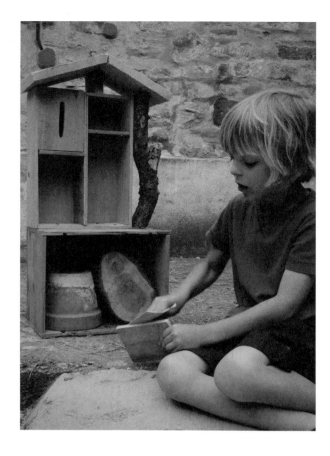

2. Create the outline of your bug hotel by assembling the structure. We joined our crates together with screws, and then mounted the structure onto a piece of scrap wood to give it some extra support. Since we had decided to hang our bug hotel on a wall, we needed the platform to help support the weight.

3. Using pieces of scrap wood, create compartments within the crates. You can saw small panels from your wood or plywood, sand them for a precise fit, and nail them into place (from the outside of the box inward) with a few small carpentry nails.

4. Fill the compartments with pine cones, dry leaves, and sticks. You can even create a tiny dry stone wall! We filled up the space under the roof with a wall of sawed-off bamboo. We dipped the bamboo tubes in glue before adding them to the hotel to make sure they stayed in place.

5. Cut a piece of fine-mesh chicken wire to cover the area where you have filled compartments with loose materials and fasten it to the front of the hotel with a staple gun.

6. Drill holes in a wooden log or tree stump to create burrows for solitary bees. You can drill many holes in different sizes, but don't drill them all the way through.

 SAFETY TIP

Saws, drills, nails, staple guns, and chicken wire can be dangerous and should be used with adult supervision.

INSTRUCTIONS

1. If you're using crates or drawers to make a composition, try different ways of putting the crates together until you find a shape you like.

7. Fill a terra-cotta flowerpot with straw and dry leaves and add that, turned upside down, to a compartment.

8. Create a butterfly shelter by filling a space with twigs and dry leaves. Close the shelter with a wooden lid with a narrow slit. Butterflies like to rest in safe, secluded spaces, and the slit allows them to access resting spots without damaging their wings. We created the cover from a piece of scrap plywood. We drew a slit with a pencil, drilled a small hole at the center, inserted a small fret saw, and carefully cut out the slit.

9. If desired, use a few wood planks to create a roof to make your bug hotel look like a small house. (Keep in mind that if you're going to place your bug hotel in a place that isn't sheltered from rain, you might want to add some kind of protective roofing material to prevent the wood from rotting.)

10. To install your bug hotel in a garden, either hang it on a tree or a wall (making sure it's at least 5 feet above the ground) or simply mount it on a stake. Make sure it's located in a warm, sheltered spot and close to flowers for the pollinators to visit!

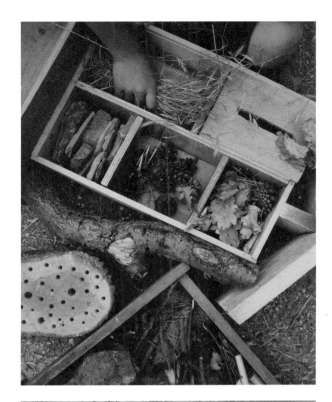

HANDCRAFTED
BIRD NESTS

Discovering a bird's nest in the wild feels like a secret joy. The nest might be the pendulous weaving of an oriole, the red-winged blackbird's twiggy structure tucked between marshy cattails, or the humble swallow's mud-cup sculptures under the rafters of an old barn.

To the wild and free heart, a nest carries the ethereal delicacy of a fairy tale. It may be common, but it is nonetheless extraordinary. Many abandoned nests can be gathered, sealed in a bag or airtight container for a few weeks (to get rid of any unwelcome remnants such as mites), and then displayed as a beautiful addition to a collection of natural curiosities.

Always confirm that the nest is truly abandoned before removing it. It is important to be aware of local, regional, and national wildlife laws regarding active nests, because most bird species are protected and any tampering with or removal of their active nests can potentially lead to fines or penalties.

As an ecologically gentle alternative to collecting a nest from outdoors, building your own nest out of natural materials can be a lovely spring craft that creates a focal point for a seasonal nature table or a striking decorative element in your home. This craft certainly kindled a deeper reverence in our home for a bird's remarkable process of fashioning ordinary materials into something so intricate and truly elegant.

MATERIALS

Air-dry clay

6 sticks of equal length, 4 to 5 inches long

Large bunch of long vines, creepers, green willow, or flexible grasses or weeds

Dried moss or small feathers (for lining the nest)

Decorative elements such as twigs, sticks, dried flowers, leaves, fungi, or small feathers

Twine or natural-looking string

1 or 2 clothespins or similar clamps

Acrylic paint (for painting eggs)

Optional: stones or acorns to resemble eggs

INSTRUCTIONS

1. With the twine or string, tie the ends of your 6 small sticks together to form 2 separate triangles. Tie one of the triangles on top of the other to form a star shape that will serve as the base structure of your nest.

2. Begin twisting long lengths of vines into a circular wreath roughly the size of your star base, weaving the ends over and under as you work around. (A clothespin can help keep the circle together for smaller hands at the beginning until it can be secured with twine.)

3. Continue threading more vines into the wreath until you are happy with its thickness and stability. We enjoy the natural look of leaving a few of the ends poking out here and there. Place the wreath on top of your star base and tie them together in a few places underneath with the string until they are sturdily connected.

4. Take a golf-ball-size piece of air-dry clay and pinch it into a shallow cup shape.

5. Carefully nestle the cup down into the nest's cavity. It will dry solid over the course of a day or two.

6. Fill any gaps in your nest's exterior with extra twigs, leaves, buds, flowers, or other natural materials.

7. Place a few tufts of moss or small feathers in the center of the nest to cover the clay cup.

8. Shape eggs from the clay and allow them to dry for 24 hours. Paint them white, and then splatter-paint them with brown acrylic paint.

9. Tuck the eggs, or a few stones or acorns to resemble eggs, into this home-sweet-nest. Display ideas include nestling the nest in the fork of a fallen branch, in the curve of a large grapevine wreath on your door, atop a stack of books, or inside a wooden bowl or terra-cotta pot.

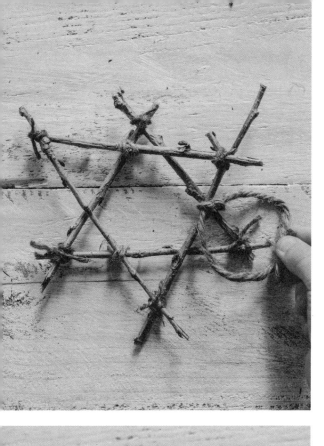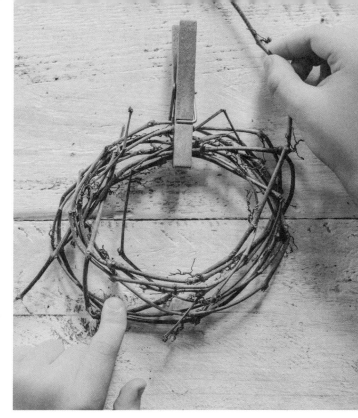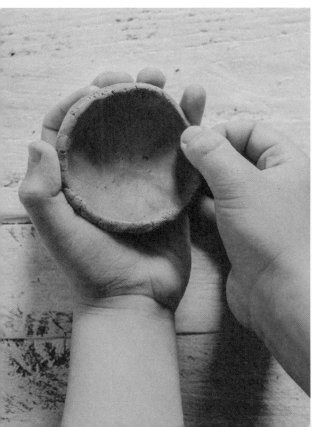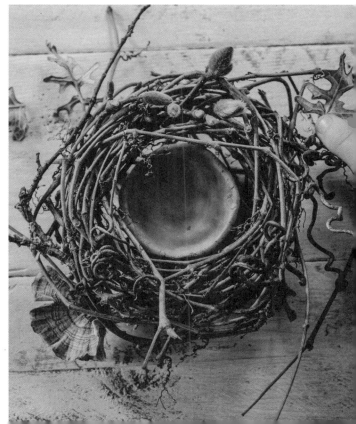

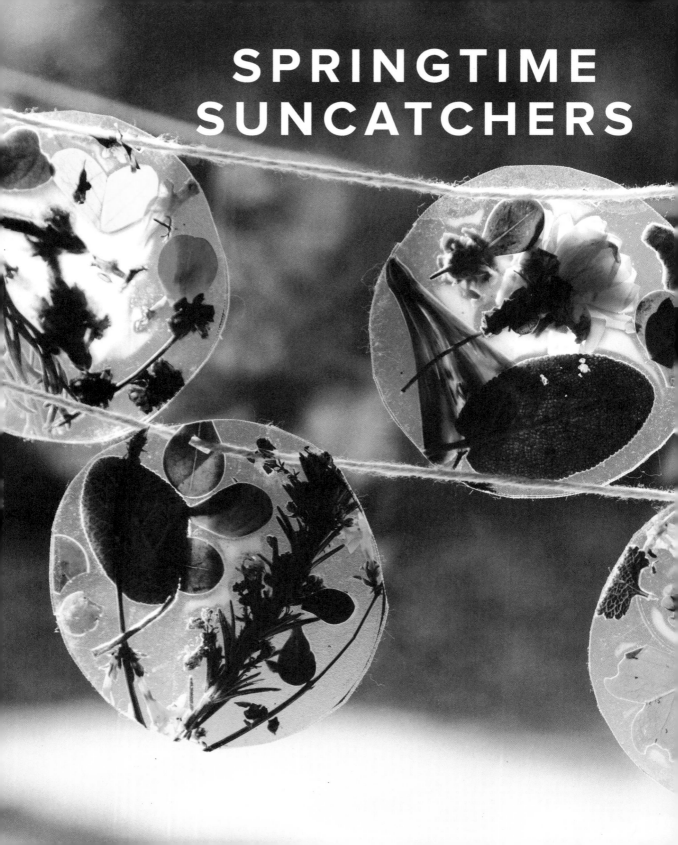

SPRINGTIME SUNCATCHERS

The arboretum at our local university has become a special spot where my children and I enjoy observing flowers and trees through the seasons. Admission is free, and there are no rules against respectfully gathering a few specimens to take home. We have been able to learn the names of many native plants, thanks to the identification labels and exhibits around the gardens. The green meadows, sturdy climbing trees, and picnic tables invite us to linger out of doors for the afternoon.

I've found that a loosely structured game or task can direct our attention and help our powers of observation come to life. An activity that has often helped us ease our way into the habit of observing and enjoying the outdoors is a nature hunt. We do them year-round, strolling the sidewalks of our neighborhood, ambling along garden paths, or hiking in the foothills near our home.

We usually take along a basket for our treasures (though on spontaneous outings, it's my stroller basket). Sometimes I ask my children for specific objects to bring back, while other times I guide them by giving them features to look for in the landscape, such as a color, texture, or size. Which plants are prickly? Can you find something with soft leaves? Is that cactus taller than you are? After a few questions like these, they are soon off exploring on their own. When our basket is full and the environment has been thoroughly inspected, our time of discovery usually gives way to free play.

On one particularly beautiful spring day, we chose to do our nature hunt in a Mediterranean garden, a local exhibit known for its medicinal and culinary herbs. While some of the plants lay dormant for the season, others continued blooming in the mild winter climate. After tiny roses, sprigs of lavender, and soft lamb's ear were gathered, my girls took off toward the oak groves to rush through leaves and climb on the low, hearty branches.

Young children take their nature treasures very seriously (I have learned this the hard

way), so I'm always on the lookout for new ways to preserve our findings. The colors and textures in our basket presented the perfect opportunity to make springtime suncatchers. This simple but stunning craft can be done with items you probably already have around the house. Or go on a nature hunt of your own to find new treasures to incorporate into your suncatcher!

MATERIALS

Clear contact paper

Scissors

Pen

Tape

Large jar lid
(for tracing circles)

Single-hole punch

String or twine

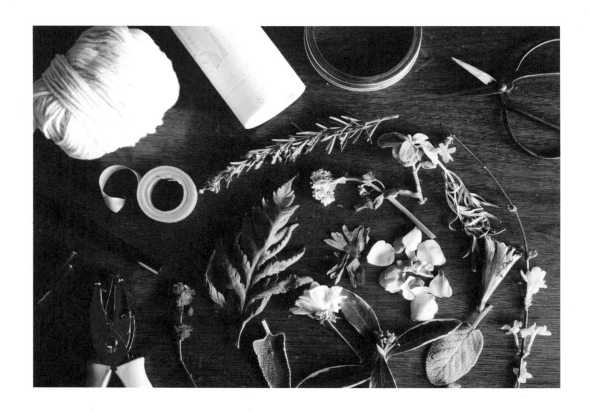

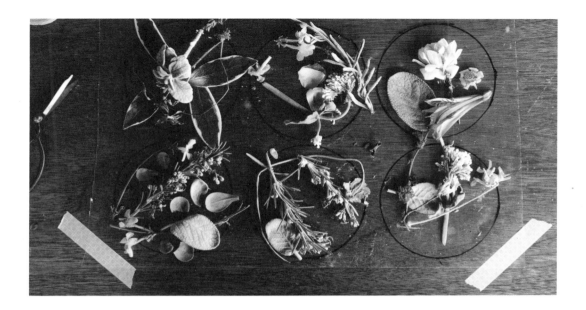

INSTRUCTIONS

1. Begin by cutting a sheet of contact paper. Tape the corners of the paper to your work surface, clear side up, to prevent the edges from rolling up. Using the jar lid, trace circles onto the contact paper.

2. Untape the contact paper and peel the backing off. Flip it over so that the sticky side is now facing up (your traced circles will show through). Retape the corners of the paper to your work surface.

3. Now you have a sticky surface perfect for placing flowers and leaves on. Let your child fill the circles with their treasures. We used everything from twigs to lily blooms, but found that flat, translucent objects looked prettiest in the sun, particularly small leaves, petals, and compressed flowers. Don't worry about keeping everything in the lines!

4. Cut a second piece of contact paper approximately the same size as the first or larger. Peel off the backing and lay it sticky side down on top of your filled circles, so that the nature treasures are sandwiched between the two sheets. Have your child smooth the paper to adhere it securely.

5. Cut out the circles and punch 2 holes in the top of each. If you like, you can place the circles in books overnight to compress them further. String the circles together to make a garland. Hang in a sunny window and enjoy!

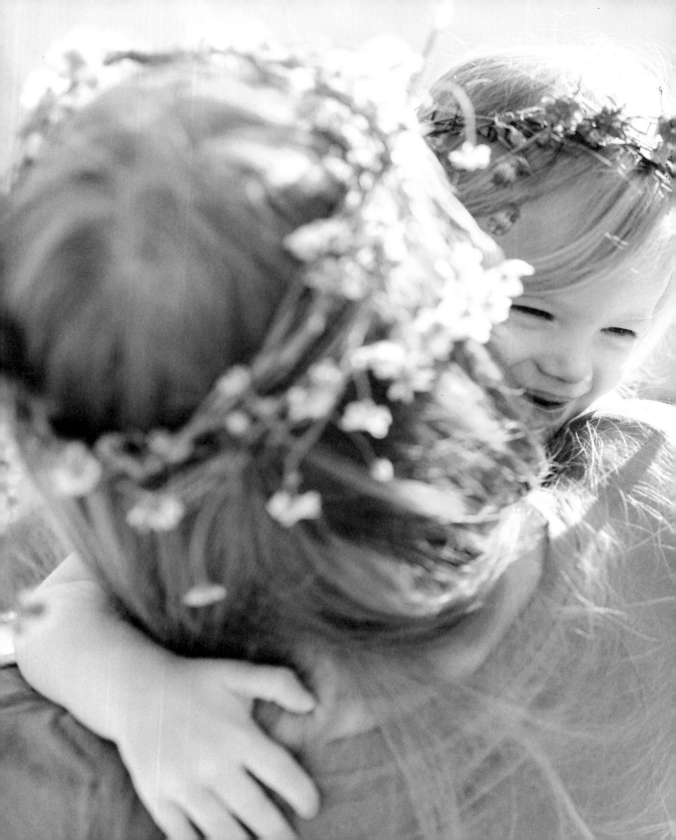

SUMMER

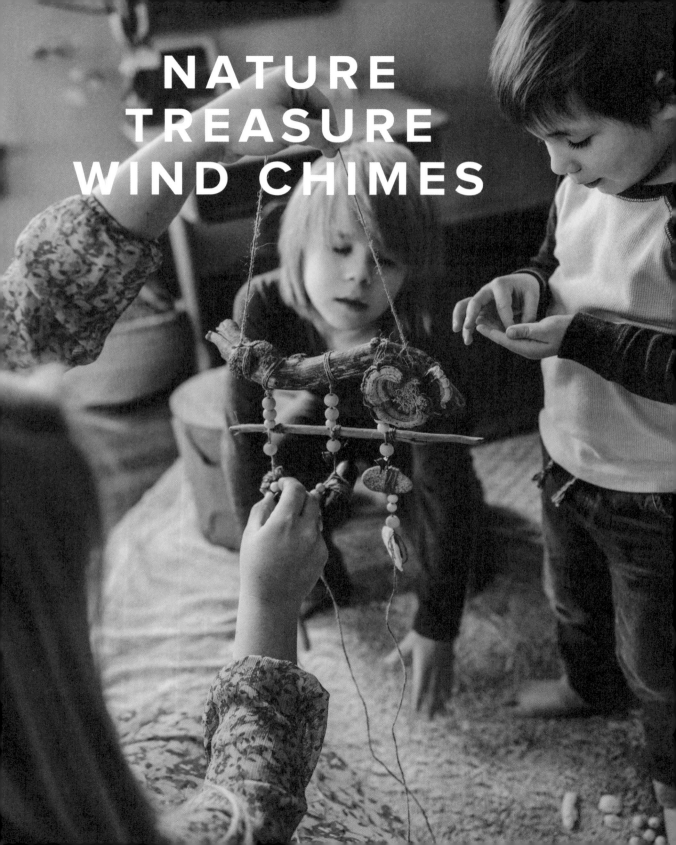

NATURE
TREASURE
WIND CHIMES

The winds of my childhood in tropical West Africa always carried a dry dust with the sounds of distant tribal drums, or the loamy smell of wet clay and rotting fruit in the season of rains. Now that I am grown and live in Pennsylvania where the seasons are four instead of two, it excites me to still be discovering the differences that animate the northern cycle.

The spring winds here carry mostly the pungent animal smells of the surrounding farmlands. But my boys and I still prefer to be outdoors letting that wind tangle our hair while we stuff our pockets full of natural treasures that were buried so long under winter snow and frozen earth. Seeing my children grow excited over a simple odd-shaped stone or lost feather or tuft of moss still stirs that familiar childhood wonder in my heart that thrills to encounter raw and natural beauty.

Combining these beautiful gathered trinkets into a wind chime is both an artistic and a functional way to utilize some of our collected items. It can also be a rich trial-and-error exploration of the concepts of balance, weight, and symmetry while celebrating the seasonal music of our lives together.

MATERIALS

Length or two of sturdy driftwood, a branch, or a piece of salvaged wood; must be strong enough to support the items you plan to hang

Nature elements (responsibly collected stones, shells, smaller sticks, feathers, etc.)

Natural wooden beads (have children paint them if they prefer color)

Small craft bells

Twine or hardy string

Scissors

Optional: hot glue, moss, lichen, or dried fungi for decorating

 SAFETY TIP

Hot glue can be dangerous and should be used with adult supervision.

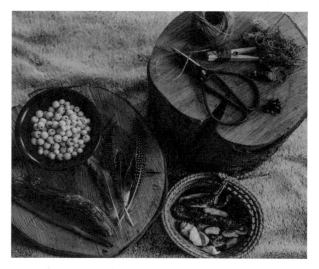

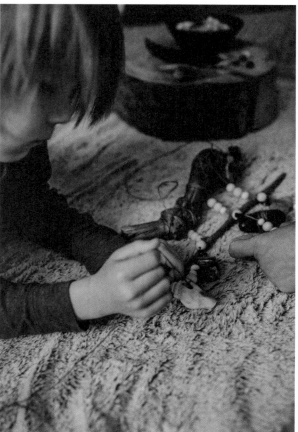

INSTRUCTIONS

1. Tie a strand of twine securely to both ends of your chosen piece of wood as the means for hanging your final piece. We glued moss and dried fungi to the wood for decorative value.

2. Tie 3 pieces of string in even increments along the wood, making sure they will each be long enough to hold your treasures, plus extra length for potential layering around the items without holes. (Any excess can be trimmed off at the end.)

3. Begin tying or threading your nature elements securely, from top to bottom, winding and knotting multiple times around heavy or odd-shaped items as necessary.

4. String wooden beads and a few bells between each treasure as you go, to add aesthetic and musical value as well as to help prevent potential tangling. Feathers placed near the bottom will catch the wind and aid in creating movement in your wind chime.

5. Hang your finished wind chime in a window, over a porch, or anywhere that will catch a cheerful summer breeze!

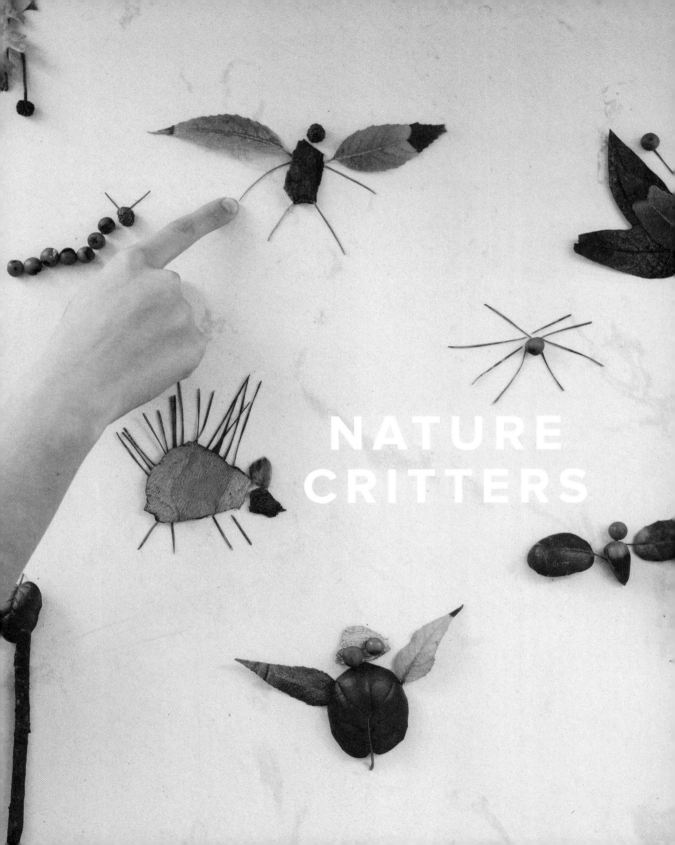

NATURE
CRITTERS

recently took my girls to a natural area where we looked for leaves, sticks, seeds, and berries. They had great fun gathering all sorts of goodies, and once we got home they poured out their finds onto the counter. I suggested that we create critters out of what we had found, and they excitedly got to work.

They took their time looking through their discoveries, using their imaginations to create hedgehogs and butterflies, turtles and bugs, as well as fairies and other creatures. This simple but fun activity kept them busy creating for quite some time, and once we finished we painted our creations in our nature journals so we could remember them.

MATERIALS

Leaves, sticks, seeds, berries, and any other nature treasures that catch your eye

INSTRUCTIONS

1. Gather your nature goodies in a treasure hunt.

2. Spread out your finds on a workspace.

3. Look through your findings, imagining and discussing ideas for possible critter creations.

4. Layer leaves for texture and add berries for color.

5. Paint the creations in a nature journal so you can remember them.

TIP: Here are some ideas of topics to discuss while working on the critters, as well as follow-up activities:

- Identify the leaves, berries, and bark you used.
- Label your page with whatever foreign language you're learning.
- Draw a bird you saw while collecting your nature treasures.
- Describe the weather you experienced on your outing.

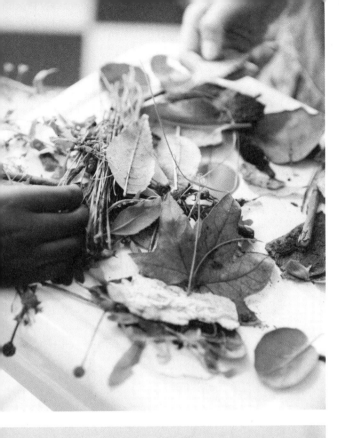
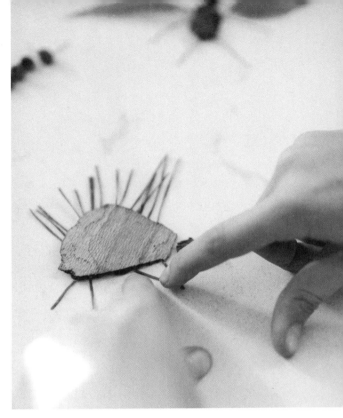
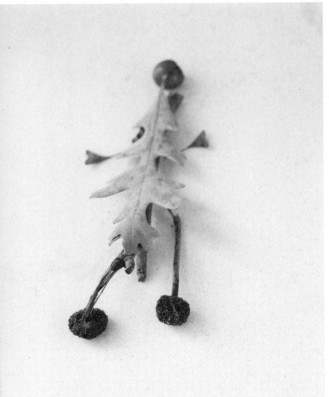
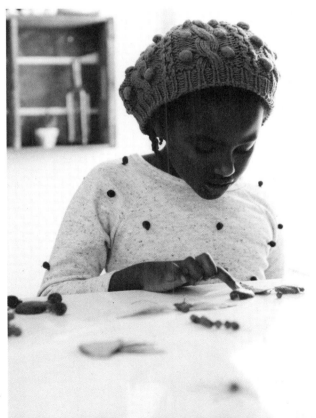

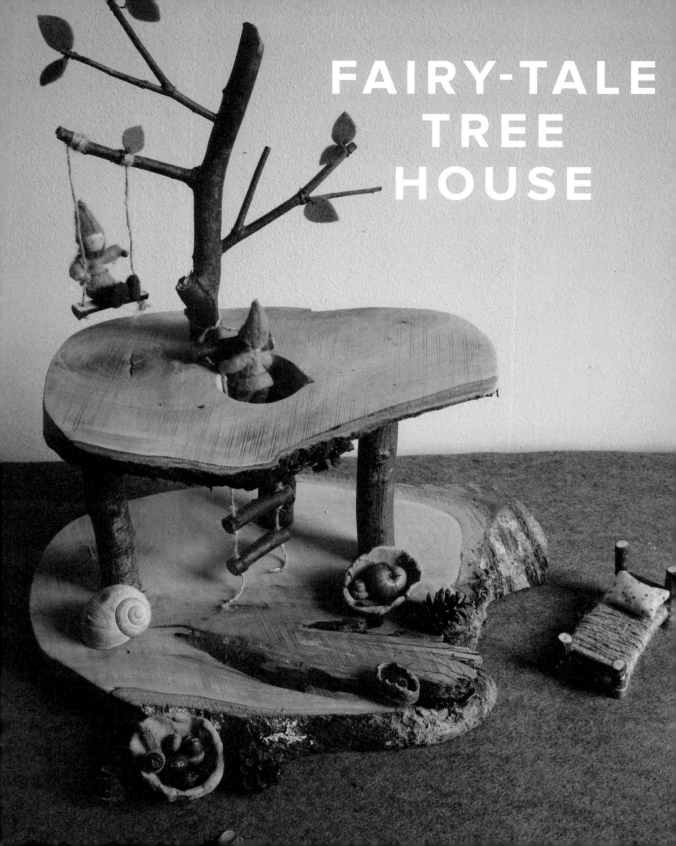

FAIRY-TALE TREE HOUSE

I love to watch my boys get lost in hours of unstructured, imaginary play. They get wrapped up in a story plot that unfolds like their own private fairy tale built with experiences and stories from the world that surrounds them. They jump down the rabbit hole (or squirrel den) and wander into a wild and beautiful world where their dreams come true and their fears become dragons that need to be tamed. It is here that they come to transform what they have seen and heard into something that is their own. It is here that they learn and grow.

We often turn to crafts to create something that can play a role in these adventures: a wooden dragon for Michaelmas, a new set of felt gnomes, and, of course, this whimsical tree house.

MATERIALS

2 large slices of wood (one should be slightly smaller than the other with a hole approximately 2 inches across for the ladder; the slices can be natural wood, even with the bark still attached (we used wood from a cherry tree we had to cut down two winters ago, but any soft wood, such as linden or beech, would work as well); the thickness of the slice isn't important as long as you can cut through it)*

240-grit sandpaper

3 or 4 chubby sticks with a length of 5½ inches

1 branch that can be turned into a little tree

1 straight branch, about 1½ to 2 feet long, to cut into lengths for a rope ladder

Wood glue

Hemp string

Pencil

Scissors

Small saw

7 to 9 wooden pegs for woodwork assembly, or a fine wooden rod to cut up into pegs approximately ¾ inch long

Drill

continued

* If you can't find any natural wood, you can use thick plywood instead. Plywood is lighter and easier to cut than natural wood, so if you would like your child(ren) to be able to help with this project from start to finish, then this might be a better option.

Drill bit to match the pegs

Fine drill bit to make holes for the rope ladder

Optional: wool felt for leaves, thin metal wire

⊕ SAFETY TIP

Saws, drills, and wire can be dangerous and should be used with adult supervision.

INSTRUCTIONS

1. Sand the wood slices until they're perfectly smooth. (Make sure the inside of the ladder hole is sanded as well.)

2. Make sure the chubby sticks are all exactly the same length; trim as needed. Position them on the larger wood slice, which will be the ground floor. Place the smaller slice on top of these stick pillars to test the composition.

3. Once you're satisfied with the composition of the tree house, draw around the pillar sticks with a pencil to mark their placement on the bottom board and on the underside of the top board.

4. Drill holes in the center of your marks and in both ends of the sticks.

5. Apply glue to the pegs and insert them into the holes to assemble the tree house.

6. Drill a small hole in the bottom of the branch that will become your tree and drill a hole in the board where you want the tree

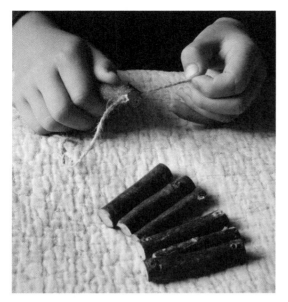
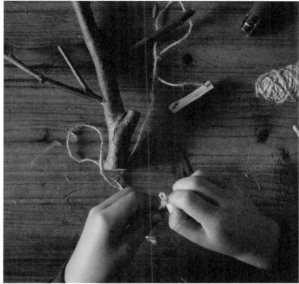

to be. Apply some glue to a peg and insert it into the branch. Dip the other side of the peg in glue and "plant" your tree.

The basic structure of the tree house is now ready. The next step is to make the rope ladder.

1. Cut the straight branch into 7 to 10 short sticks of about 2 inches each.

2. Drill tiny holes through both ends of the sticks, making sure the holes are aligned.

3. Cut 2 lengths of string and tie a triple knot at the beginning of both strings.

4. Thread the strings through the tiny holes in one stick and slide them through so the stick comes to rest on the knots. Make

2 more knots at approximately 1 inch from the first ones.

5. Thread the strings through the next stick and repeat the steps until the rope ladder is the desired length. Use the ends of the strings to tie the ladder to the base of the tree.

6. If you like, you can use this same technique to make a small swing.

7. Lastly, you can attach felt leaves to the tree branch by attaching a felt leaf to both ends of a small piece of wire. Bend the wire back, twist it a few times onto itself to secure the leaves in place, and wrap the wire around a branch of the tree.

FLOWER CROWNS

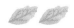

Pick wildflowers and weave them into a crown, spread out a quilt in the grass for a picnic, embrace the warmth of the sun on your skin, and make believe with your children.

BRAIDED FLOWER CROWN

MATERIALS

Assorted flowers with long, skinny stems

INSTRUCTIONS

1. Pick wildflowers and pull off extra leaves.

2. Take 3 flowers and braid the stems together.

3. After braiding a bit, add another flower on top of the middle stem and continue to braid.

4. Repeat this process until you've reached your desired crown length.

5. To finish, form a circle and weave the end of the stems into the braid at the beginning. Tie another flower in a knot around this area to secure it.

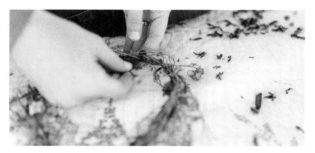

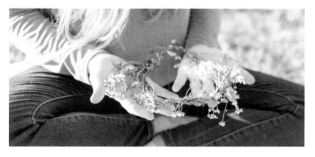

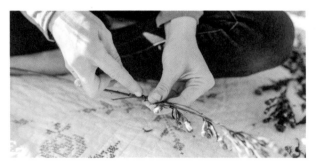

TIED KNOT FLOWER CROWN

MATERIALS

Assorted flowers with short, bendable stems

INSTRUCTIONS

1. Pick wildflowers and pull off extra leaves.

2. Tie one stem to another in a knot with the flowers facing the same direction.

3. Tie another flower to the stem of the second flower.

4. Continue to tie flowers to each other, all facing the same direction, until you have reached your desired crown length.

5. To finish, form a circle and tie the end of the last stem to the beginning stem just below the flower.

SLICE FLOWER CROWN

MATERIALS

Assorted flowers with long, thick stems

Optional: small knife

 SAFETY TIP

Knives can be dangerous and should be used with adult supervision.

INSTRUCTIONS

1. Pick wildflowers and pull off extra leaves.

2. Using your fingernail or a knife, slice a small hole vertically through the middle of a stem.

3. Take another flower and push its stem through the hole you created. Make sure the flowers are facing the same direction.

4. Repeat this process until you have reached your desired crown length.

5. To finish, slice through the first stem just below the flower and push the last stem through to form a circle.

TIP: Once you are finished, if there are any sparse areas on the crown, tie a flower with a bendable stem around that area. This will fill in the empty spot while also helping to secure the crown. Continue this process until you are satisfied with how full the crown is.

POTTERY CLASS

BY HANNAH MAYO

My boys run through the wooden gate into Miss Lani's backyard where her outdoor pottery studio resides. They're eager to find out who will be first on the wheel today and if any of their previously made pieces are ready to bring home. As a former science teacher and mother of three, now a working ceramic artist, Lani has a natural ability to teach and has humbly and graciously shared her skill with our community. Even on afternoons when twelve or more children show up for class, Lani is smiling and calm as she helps each one in turn.

For both of my sons, working on the wheel is the highlight of pottery class. They love molding the soft clay into bowls and cups using their own hands. When we started learning pottery from Lani two years ago, my eldest took to the wheel immediately and has filled our kitchen cupboard with various vessels that we use for everything from cereal to guacamole. He is incredibly proud of having made these beautiful and functional objects for our family.

While waiting for a turn on one of the two wheels, children sit together at tables either hand-building with clay or glazing items they've made in previous classes. Miss Lani sometimes shows examples of things they could make, but she primarily encourages their imaginations to run wild while teaching the fundamentals of scoring, smooth-

ing, making hollow objects, and other important concepts. All manner of clay creature and creation might be found on the shelves of Lani's little studio—dragons, monsters, fairy houses, and more, straight from the minds and hands of these five- to ten-year-old students. Even at the age of three, my younger son had a chance to feel and form some clay spinning on the wheel with his small hands. With some of my help, he made his first bowl when he was four and has gradually become able to do more and more on his own.

There is a delightful and soothing sensory element to pottery that I see children respond to with enthusiasm. Hands slip over wet clay, and one can feel the object take shape and change with each touch. They love it for the same reasons they love playing with mud, but all the more so because it feels empowering to make something real and useful, especially at such a young age.

We pile back into the car after class, smudged with clay and chattering about what we'd like to make at our next class. I'm grateful to have found this opportunity to learn this beautiful art form.

Pottery trains the hands and brain to work together in an entirely new way, learning to feel instinctively for balance, thickness, shape, and the way to form the thing you have in mind. Skill is only acquired through consistent practice. The practice pays off in gradually seeing your pieces more closely match your vision and become more useful for their intended purposes. These are such valuable lessons for children to learn: the diligence, the hand-brain connection, and the muscle memory of the craft itself will be carried with them throughout their lives.

CALENDULA
SALVE

The first year our family planted calendula seeds, I had no plans for the petals. The seeds came in a package of mixed flowers, which we planted rather haphazardly one July after we had harvested our garlic. It wasn't until the fall, when most of the garden had faded, that I really took notice of the vibrant blooms. Even after a series of cold nights, the golden flowers turned up their bright orange and yellow faces toward the sun.

As my little girls gathered bunches of the hardy beauties to bring inside on a chilly October afternoon, I felt the slightly sticky resin on their fingers and began to wonder what exactly these flowers were. It wasn't until I looked back at the old seed packets that it dawned on me: we had the makings of calendula salve growing in our very own soil.

I had purchased calendula cream for years: for my pregnant belly, for our babies' tender skin, for bee stings and mosquito bites, and for hands weathered from garden work. But until this moment, it had not occurred to me that we could make our own.

Doing a little research into herbal wisdom, I discovered that ancient Egyptians used calendula to rejuvenate their skin, and the ancient Greeks and Romans used it as a culinary garnish. Europeans and early American colonists relied on calendula's gentle immune-boosting properties for protection against the illnesses that come with the damp cold of winter.

Making calendula salve is much easier than you'd think. And if you don't grow calendula in your garden, you can find dried petals in the bulk section of natural food stores or order them online from an herb supplier.

Note: This craft requires 2 weeks for soaking the dried petals before you get started on the salve, and an additional 2 weeks if you are starting with fresh petals.

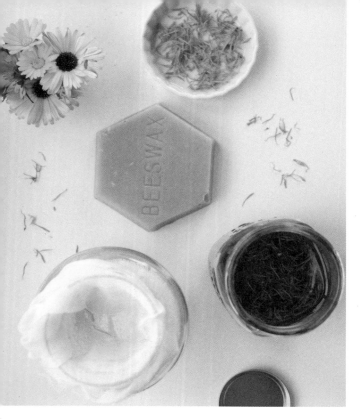
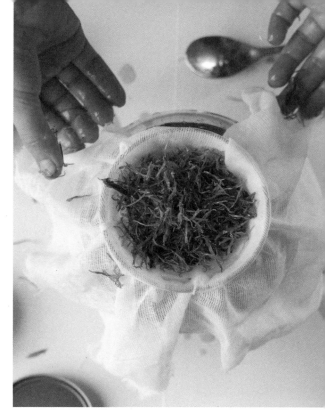
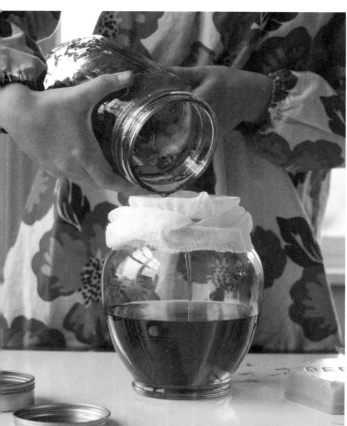
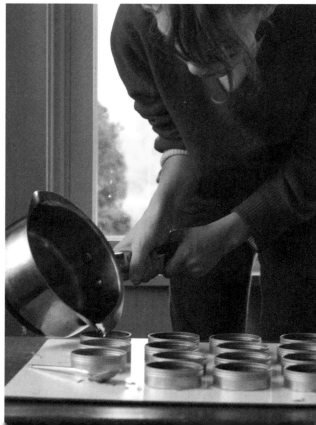

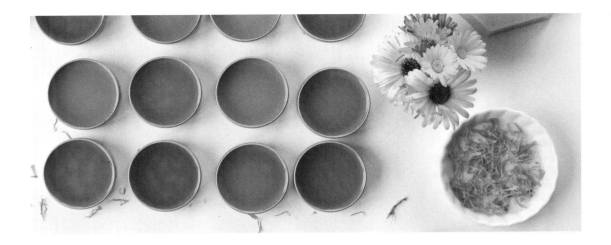

MATERIALS

¼ cup dried calendula petals

¼ cup beeswax, about 2 ounces

½ cup olive oil

Cheesecloth

Pot or slow cooker (consider dedicating one to this use, as the wax is difficult to remove)

Optional: 20 to 40 drops lavender essential oil

 SAFETY TIP

Heating elements and hot oil and wax can be dangerous and should be used with adult supervision.

INSTRUCTIONS

1. If you are starting with fresh petals, spread them out in a thin layer on wax paper and leave them to dry for 2 weeks.

2. Soak dried petals in olive oil for 2 weeks.

3. Strain the petals out of the olive oil using cheesecloth or a similar material.

4. Heat the calendula-infused oil just slightly in a pot on the stove over low heat or in a slow cooker. Add beeswax. (We melt our beeswax in a small slow cooker reserved for this purpose, but you can also buy beeswax in pellets and add them directly to your pot.) Add lavender essential oil if desired.

5. Carefully pour the liquid into 2-ounce tins (or lip balm containers). It will harden as it cools, in 2 to 6 hours.

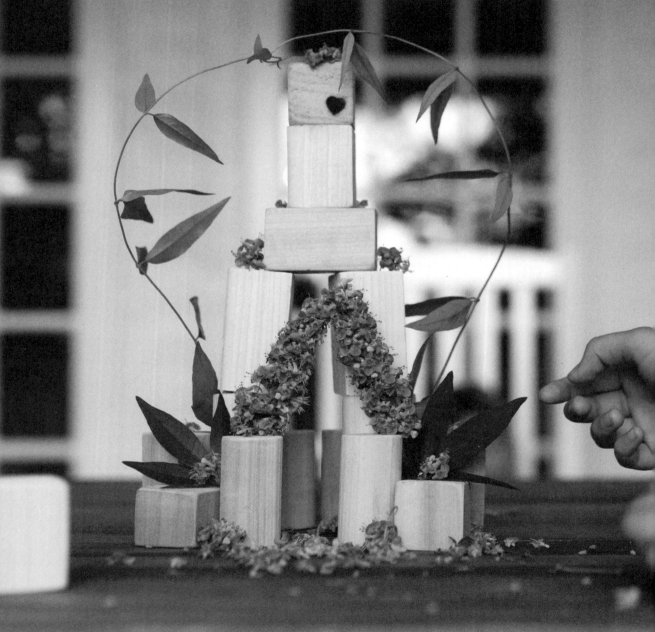

WOODEN BLOCKS

Wooden blocks are a classic childhood toy. They ignite the imagination and invite children into the dreamy world of creative play. Little ones develop dexterity as they learn to stack one precariously placed block at a time. Belly laughs ensue when those same hands enthusiastically knock their towers over, blocks tumbling down. As children grow, blocks become barns and palaces, museums and zoos. If blocks could talk, they would recount story upon story of our children's imaginations.

Wooden blocks are actually quite simple to make. An added bonus is that when blocks are made at home, you can rest assured that they are free from harmful chemicals and toxins, thanks to the natural antimicrobial and antibacterial properties of wood.

Technically you can do all of the work with a handsaw, but a circular saw can make things easier. We also used a homemade jig. In carpentry, a jig is a device used to make repeatable processes easier and more accurate. This simple project is a great op-portunity to teach children about jigs and hand tools (with supervision, of course). Thankfully, the list of supplies and tools you need is short.

MATERIALS

2×2-inch poplar board; an 8-foot length will yield plenty of blocks

Wooden closet dowel rod for round blocks (standard diameter is $^{15}/_{16}$ inches)

2×4-inch poplar board for the jig; you'll need only about 3 feet

240-grit sandpaper

Workbench or wooden surface to secure the jig onto

Handsaw

Drill

Screws

Optional: wood burner, olive or coconut oil, beeswax, glass measuring cup (beeswax can be difficult to remove, so choose the measuring cup accordingly), pot, tin for storing sealant

 SAFETY TIP

Saws, drills, stoves, and hot wax and oil can be dangerous and should be used with adult supervision.

INSTRUCTIONS

1. Start by making a jig. This simple 3-piece jig will hold the 2×2 in place while you cut it into blocks. Cut 2 pieces from the 2×4, about 10 inches each in length. Pre-drill 2 holes about 1 inch from each end of each block as shown.

With the 2×2 placed on the workbench, place these two jig pieces on either side of the 2×2 and screw them into place, keeping them snuggly pressed against the 2×2. This method is fairly easy for little ones to help with.

The third part of the jig is set back 6 inches from the end and placed on top of the first two pieces. Again, screw it into place. Setting this block back 6 inches gives you room to hold down the 2×2 while you cut it with the handsaw later. Your jig is ready!

2. Slide the 2×2 through the groove you've just built with your jig and start cutting blocks. A few tips on using a handsaw: Let the saw do the work—you don't need too much pressure. In fact, too much pressure will cause the blade to bind up in the kerf (the groove the saw cuts in the wood). The first stroke of the saw should be back

toward you, and it should be a very gentle pull to get things started. You may have to perform several back pulls to get your kerf started. Keep the saw at about a 45-degree angle for maximum efficiency until your cut is nearly complete, then flatten it out to a shallow angle for a clean finish. When little arms tire, you can do the cutting or use a circular saw if you'd like.

3. Cut your blocks into various lengths. We cut ours into 2-, 3-, and 4-inch lengths.

4. Have a family sanding party. I promise it will bring joy to all!

5. Optional but recommended: Use a wood burner to burn a shape of your choice onto a few of your blocks, making them extra special. Your blocks can become a unique and personalized multigenerational family toy.

6. If you would like to seal your blocks, you can make your own natural sealant using 3 parts olive or coconut oil to 1 part beeswax. Place both ingredients in a glass measuring cup. Place the cup inside a small pot filled about halfway with water, making a double boiler. Heat over a medium-low flame until the beeswax melts. Stir and pour into a tin or glass jar. When cool, rub onto your blocks with a soft cloth.

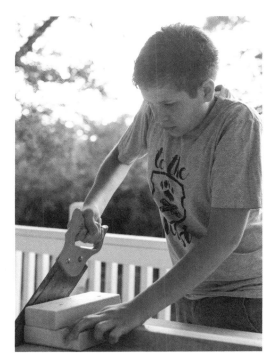

PORTABLE FLOWER PRESS

April has come and gone, and nature is about to burst into its full abundance. Here in Northern Italy, roses have started to bloom in the garden, and poppies are peppering the fields with bright pops of color. And what better way to prepare for summer than to make a flower press to bring along on those wild and free adventures among the wildflowers?

MATERIALS

Sheet of plywood

Four bolts with butterfly wing nuts

Drill with drill bit to match the bolts

Small fret saw

Medium-grit sanding paper

**Corrugated cardboard
(we used an old cardboard box)**

A few sheets plain white paper

Pencil

Optional: a few pressed flowers, paper glue, nontoxic non-glossy transparent varnish

SAFETY TIP

Drills and saws can be dangerous and should be used with adult supervision.

INSTRUCTIONS

1. Using a pencil, draw the outline of the flower press onto the plywood. For this project, I used a suitcase-shaped silhouette. (To ensure both sides of the press come out identical, draw and cut out one piece and use it as a template for the second.)

2. With the fret saw, carefully cut the suitcase-shaped cover piece from the plywood.

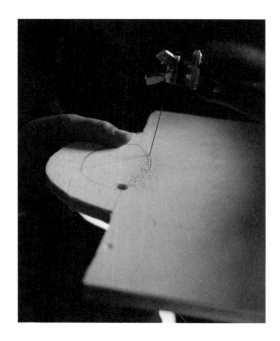 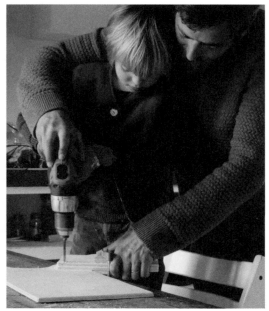

3. Drill a small hole, insert the blade of the fret saw through the hole, and cut out the gap to create the cover handle.

4. Repeat for the second piece.

5. Using sandpaper, round the corners of the covers and smooth all the rough edges. We made our boys some simple tools by covering a small block of wood and a pencil with sandpaper to make it easier for them to hold the paper and smooth the inside of the handle.

6. Drill holes in each of the four corners of each piece. To make sure the holes are aligned, drill through both covers at the same time. Because this means drilling through quite a thick layer of plywood, you may want to use a power drill with adult supervision.

7. Cut 4 pieces of corrugated cardboard and white paper to match the covers.

8. Assemble the press, alternating layers of cardboard and white paper in a sandwich between the wooden covers and inserting the bolts.

9. Decorate the flower press cover as de-sired—a painting, a drawing, or a name or poem in calligraphy. We chose to make a collage with a few pressed flowers, glue the collage to the cover, and seal it with a pro-tective varnish.

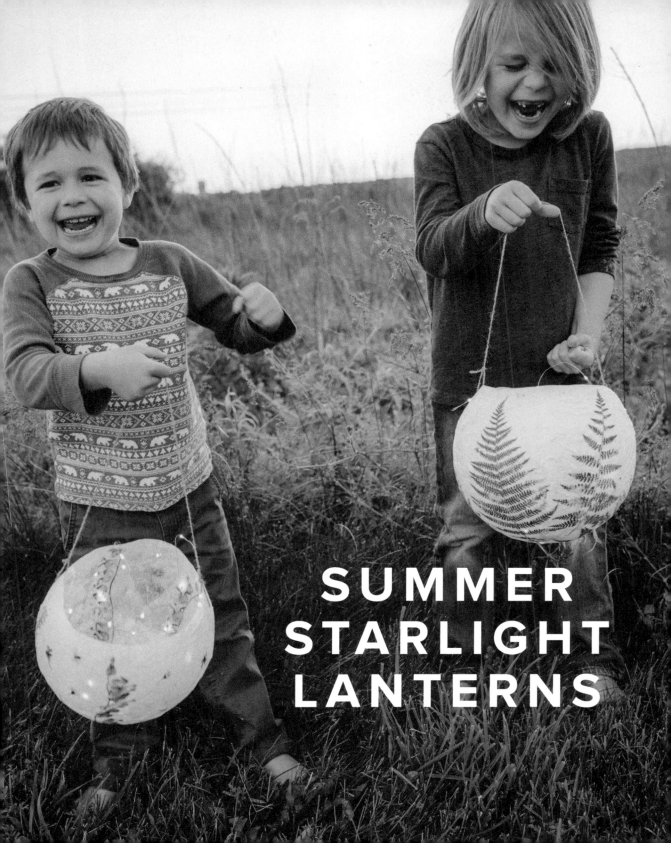

SUMMER STARLIGHT LANTERNS

Summer is such a jubilant celebration of light. It feels as enchanting and simultaneously fleeting as the warm haven of childhood—both such tender seasons of curiosity and delicate dreams. I am heeding the wisdom of ancient mothers who have urged me to cherish this time in all its ordinary beauty and brevity.

The moment I first pulled the wriggling bodies of my babies against my chest, I suddenly shouldered the invisible and profound weight of all my fragile hopes and dreams for their futures. It is an honor to witness my children become increasingly more independent in their thoughts and ability to explore the world, yet peering protectively into the future they will someday indwell is like trying to focus my eyes on the distant edge of a twilight-faded field.

Will they value kindness above fortune? Will they do the hard work of standing up for those without a voice? Will they be seekers of truth and notice beauty? Who among us doesn't dream that our children will be beacons of goodness in a world that sometimes flickers between light and shadow? Nurturing these precious days of togetherness with them is the worthy work of threading together our family values like a string of stars—a gift of steadfast love to illuminate whatever path their young hearts choose to forge.

I trust that in many places along the journey of their lives, they will be inspired to light new fires and ideas with the kindling of their unique dreams. But I also hope they will be able to lift up the familiar glow of my wildfire love that was offered with the long-ago dream that they would walk bravely through their world as carriers and sharers of light. This craft of starlight lanterns embodies this wish—and is a fun handcraft to make with your kids.

Note: This craft requires a few days for the lantern to dry in the middle of construction, so take that into account when planning your starlight lantern party!

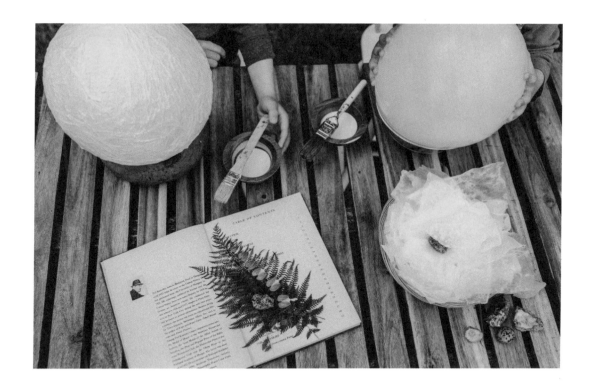

MATERIALS

Assortment of pressed flowers, ferns, leaves, grasses, etc.

1 balloon

2 bowls (one to hold the glue-and-water mixture, one to hold the balloon)

White washable craft glue

Water

Paintbrush

White tissue paper

Single-hole punch

Twine

Strand of battery-operated twinkle lights

INSTRUCTIONS

1. Begin by gathering a collection of flowers, ferns, leaves, or grasses and pressing them in a flower press or between the pages of a heavy book for a week or two.

2. When you are ready to begin constructing the lantern, blow up your balloon to the desired size of your lantern and place it snugly into a bowl with the tied end down.

3. Tear the tissue paper into random shapes and strips. Larger pieces are easier for little hands to work with.

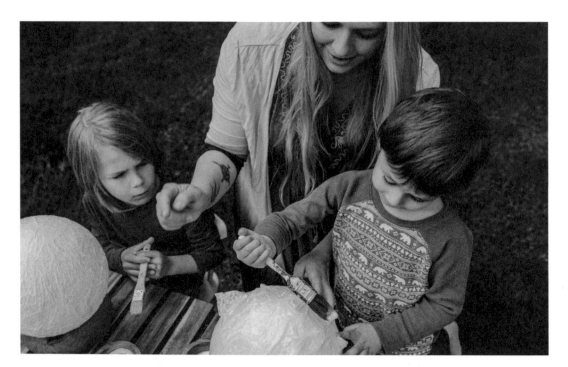

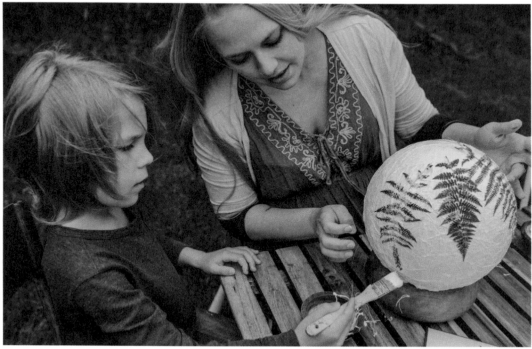

4. Combine about ⅔ cup glue with 2 tablespoons water in your second bowl. If you run out later, mix another batch.

5. Begin painting the glue mixture onto the balloon and applying tissue paper on top of that in alternating layers, covering the balloon with approximately 4 to 5 layers. Be sure to stop the tissue paper layer an inch or two above the rim of the bowl; any unevenness around this edge can be trimmed off later.

6. While your last layer is still wet, gently drape your pressed nature elements onto the surface in a pattern you enjoy, and then cover the leaves and flowers with one last layer of tissue paper. We found that some of our thicker items attached more easily when we painted a few larger brushfuls of glue over the tissue paper underneath and again on top of the nature elements before covering them with the final pieces of tissue paper. It may look milky to begin with, but it will all dry beautifully translucent and the details will be visible when backlit.

7. Allow the lantern to dry completely, 4 or more days based on the thickness, the number of layers, and the humidity.

8. Once the lantern has fully dried, carefully pop the balloon and remove its pieces. Trim the top edges of your lantern if you desire an even rim.

9. Punch a single hole on either side near the top and tie on a piece of twine.

10. Fill your lantern with a strand of battery-operated twinkle lights and enjoy the beautiful glow under the summer stars!

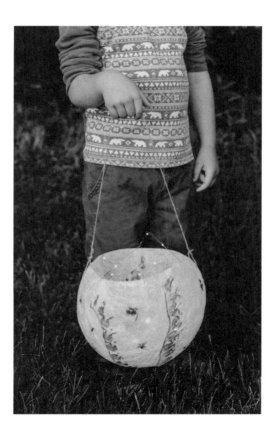

RESOURCES AND MATERIALS

Before beginning a handcraft project, always look at the materials list to make sure you have the necessary supplies. The majority of materials can be found at almost any local craft store. But listed below are a few additional places to find bulk or specialty items.

- Wool roving can be found at most craft stores, as well as weircrafts.com.

- Lip balm tubes and tins can be found at bulkapothecary.com.

- You can forage for willow shoots on your own or purchase them at doubleavineyards.com. Your local craft store may have a willow variety in their dried floral department.

- Most craft stores carry the Strathmore® brand of journals and paper, but Amazon is your best bet for the watercolor postcards.

As you delve into the world of handcrafts, you will notice that certain materials and supplies are used frequently, and you might want to begin building your own handcraft supply cabinet. Here are useful items to keep on hand:

- Twine
- Wool roving
- Craft glue
- Hot glue gun
- Scissors
- Wood burner
- Small saw
- Hand drill
- 240-grit sandpaper
- Yarn
- Fabric scraps
- Burlap

- 6-inch or 7-inch embroidery hoop

- Embroidery floss

- Tapestry needles*

- Cross-stitch needles*

- Knitting needles*

- Felting needles**

- Beeswax

- Watercolor paints

- Wooden beads

- Washable tempura paint

- Scraps of ribbon and other adornments

* These needles are usually dull, but always inspect before allowing children to use.

** Felting needles are sharp, so should be used with adult supervision.

CONTRIBUTORS

ABBY MEDAWAR is an energetic mother to four sweet children and is blissfully married to her husband. They live in Grand Rapids, Michigan, where they own and operate a family business in fine jewelry. Their time is spent reading good books, exploring in nature, enjoying a variety of ethnic foods, and serving the church and their community.

AINSLEY ARMENT is the founder of Wild + Free, cofounder of Wild Explorers Club and the Wild + Free Farm Village, host of the weekly *Wild + Free* podcast, and author of *The Call of the Wild + Free*. She and her husband, Ben, are raising their five children in Virginia Beach, Virginia. | @ainsl3y

CAROL ANN SARTELL lives on a small homestead in the Piney Woods region of Texas. Her husband is a police officer and a captain in the Texas Army National Guard. She has three small children, fifteen chickens, two dogs, and a luscious vegetable garden. She is a former public school teacher turned homeschool mama. | @farmish_life

CORY WILLIAMS is a natural-light photographer based out of Chester County, Pennsylvania. She has always cherished the photos from her childhood and has fallen in love with capturing sweet moments and memories for others. It brings her joy to see and create beauty in the people and spaces around her. | @cory_williamsphotography

DEANNA MCCASLAND is an intentional homeschooling mother who resides in a small cabin in the mountains of West Virginia where her family strives for a life of self-sufficiency. She is a lover of backyard chickens, strong coffee, books, art, and nature. DeAnna runs a photography business and teaches online courses. | @deannamccasland

ERIKA YUNG and her husband raise their children in beautiful San Francisco. After a fun and rewarding career in fashion, she now has the privilege of staying home, nurturing her kids, and pouring love, grace, and beauty into them. | @erikasjoy

HANNAH MAYO is a writer and photographer with a heart for storytelling, adventure, and human connection. She lives in South Florida with her husband and four children and has been homeschooling them since her eldest was in kindergarten. | @hmayophoto

JENNIFER NARAKI was a beloved part of the Wild + Free community. Jennifer passed away in 2019 after a long-fought battle with cancer. She was a homeschooling mama of three boys, married for seventeen years to the man she met and fell for when she was seventeen. She delighted in grace, her boys, nature, books, music, vintage, fine fare, and photography. | @jennifernaraki

KATRIEN VAN DEUREN grew up in Belgium and moved to Northern Italy when she met her husband, Francesco. Now almost ten years later, they have five-year-old twin boys and a baby and make a conscious effort to build a slow, mindful life for themselves in close contact with nature. | @growingwildthings

KRISTIN ROGERS loves to laugh, learn, make fun of herself, let her children climb on her, and join them in their homemade forts. Her heart does a pitter-patter for nature, adoption, reading, coffee, homeschooling, thrift shops, messy hair, and tattoos. | @kristinrogers

LEA WU is a recovering public-school teacher, has homeschooled her two children for four years, and also homeschools three other children. She has a passion for forest hiking and gardening (especially with children) and lives in the beautiful Great Lakes state of Michigan. | @myprojectlivewell

LEAH DAMON was raised on a mission field in the Wolof tribe of the Gambia, West Africa. She and her husband are currently raising and homeschooling their three wild boys in a vintage farmhouse in Southeastern Pennsylvania. | @leahdamon

MOLLIE HARDY is a graduate student studying social work, a lifestyle photographer, and wife to a bearded sociology PhD student. Mollie is an advocate for empathy, a believer that vulnerability is a superpower, and a lover of people right where they are—whether that's across the table with a cup of coffee or through the lens of her camera. | @mollie_hardy

NAOMI OVANDO lives with her husband and children in sunny Southern California. She homeschools her two boys and little girl, and is a hobbyist photographer who loves taking storytelling photos of her family and going on outdoor adventures. | @3bebesmama

NICHOLE HOLZE is an Iowa native now living in the South, happy to claim Arkansas as home. Mama to two incredible adventurers, she is a wanderlust-and-coffee-fueled fearless road-tripper who has been known to take off for epic adventures at a moment's notice. | @coleyraeh

RACHAEL ALSBURY lives in Northern California with her software-developer husband, three little girls, and one baby boy. She is an Enneagram Eight who loves reading nonfiction, organizing things, and growing rosemary. | @fromfaye

RACHEL KOVAC and her husband live in South Central Texas with their six children, including their third child who joined their family through international adoption. Rachel seeks out the beauty in everyday moments and is passionate about photography as a medium to document them. | @rachelstitchedtogether

TIFFANY GRIFFIN lives in Texas, is a homeschool mama of three Earth-side babes and one sweet girl who travels among the stars. She is a lifestyle photographer and visual storyteller with a deep love for capturing beauty in everyday moments, as well as a passion for poetry, all things nature, art, and thrifting. | @dear.wildlings

ZANE KATHRYNE SCHWAIGER lives on a hill overlooking Lake Michigan and fills her days with mothering her three active children and creating freelance writing and photography for organizations and individuals in support of families, farmers, and the natural world. | zanekathryne.com

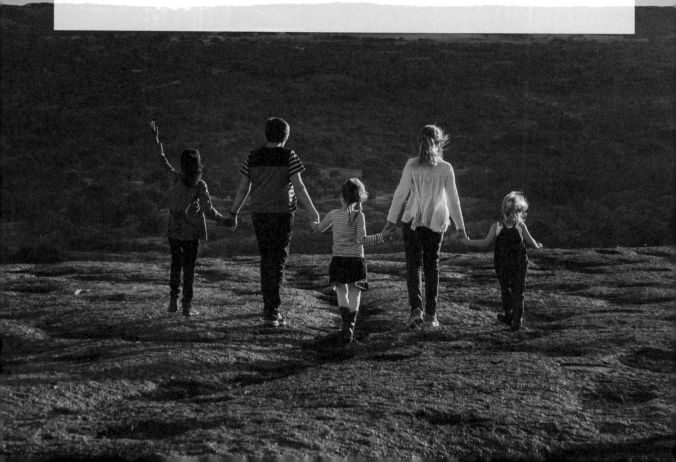

ABOUT
WILD + FREE

Wild + Free is a community of families who believe children not only should receive a quality education but also are meant to experience the adventure, freedom, and wonder of childhood. Wild + Free exists to equip families with resources to raise and educate children at home, as well as to encourage and inspire them along the way.

To learn more about Wild + Free and join the community,
visit bewildandfree.org. | @wildandfree.co

CREDITS

Photographs of Felted Acorns craft by Naomi Ovando on pages 2 and 5. Used with permission. Photographs of Branch Weaving craft by DeAnna McCasland on pages 6–8. Used with permission. Photographs of Nature Treasure Music Wands craft by Katrien van Deuren on pages 9, 11, and 12. Used with permission. Photographs of Homemade Paper craft by Abby Medawar on pages 13 and 14. Used with permission. Photograph for "Why We Do Handcrafts" essay by Kristin Rogers on pages 15 and 16. Used with permission. Photographs of Autumn Felt Embroidery craft by Erika Yung on pages 18–20. Used with permission. Photographs of Dipping Leaves craft by Zane Kathryne Schwaiger on pages 21 and 23. Used with permission. Photographs of Paper Bead Necklace craft by Rachel Kovac on pages 24–27. Used with permission. Photographs of Nature Wreaths craft by Tiffany Griffin on pages 28–31. Used with permission. Photographs of Cocoa Mint Lip Balm craft by Rachel Kovac on pages 34, 36, and 37. Used with permission. Photographs of Needle Felting Chickadees craft by Abby Medawar on pages 38–40. Used with permission. Photographs of Gnome Peg Dolls craft by Naomi Ovando on pages 41 and 43. Used with permission. Photographs of Woven Willow Hearts craft by Katrien van Deuren on pages 44, 45, and 47. Used with permission. Photograph for "The Storied History of Handcrafts in Education" essay by Naomi Ovando on pages 48 and 49. Used with permission. Photographs of Paper Star craft by Erika Yung on pages 50–52. Used with permission. Photographs of Nature Cards craft by Kristin Rogers on pages 53–55. Used with permission. Photographs of Finger Knit Bracelets craft by Rachel Kovac on pages 56–59. Used with permission. Photographs of Stick Mobiles craft by Katrien van Deuren on pages 60, 62, and 63. Used with permission. Photographs of Nature

Paintbrushes craft by Rachael Alsbury on pages 66 and 68. Used with permission. Photographs of Egg Tempera Paint craft by DeAnna McCasland on pages 69 and 70. Used with permission. Photographs of Eco-Dyed Kitchen Towels craft by Cory Williams on pages 72 and 74–77. Used with permission. Photographs of Wet Felting Spring Animals craft by Erika Yung on pages 78–80. Used with permission. Photographs of Stick Characters craft by Katrien van Deuren on pages 81 and 83. Used with permission. Photographs for "Handcraft Fairs" essay by Kristin Rogers on page 84. Used with permission. Photographs of Bug Hotel craft by Katrien van Deuren on pages 88, 90, and 91. Used with permission. Photographs of Handcrafted Bird Nests craft by Cory Williams on pages 92 and 95. Used with permission. Photographs of Springtime Suncatchers craft by Rachael Alsbury on pages 96, 97, and 98. Used with permission. Photographs of Nature Treasure Wind Chimes craft by Cory Williams on pages 102 and 104. Used with permission. Photographs of Nature Critters craft by Kristin Rogers on pages 105 and 107. Used with permission. Photographs of Fairy-Tale Tree House craft by Katrien van Deuren on pages 108, 110, and 111. Used with permission. Photographs of Flower Crowns craft by Mollie Hardy on pages 112–15. Used with permission. Photographs for "Pottery Class" essay by Hannah Mayo on pages 116 and 117. Used with permission. Photographs of Calendula Salve craft by Zane Kathryne Schwaiger on pages 118, 120, 121. Used with permission. Photographs of Wooden Blocks craft by Rachel Kovac on pages 122, 124, and 125. Used with permission. Photographs of Portable Flower Press craft by Katrien van Deuren on pages 126–28. Used with permission. Photographs of Summer Starlight Lanterns craft by Cory Williams on pages 129 and 131–33. Used with permission.

Additional photography credits:

Pages i and viii: Katrien van Deuren
Pages ii–iii and 142: Rachel Kovac
Pages iv–v and 64–65: Rachael Alsbury
Pages vi–vii and xii–1: Naomi Ovando
Pages x–xi: Hannah Mayo
Pages 32–33: Erika Yung
Pages 100–101: Mollie Hardy
Page 134: DeAnna McCasland
Pages 137–41: Photographs courtesy of each contributor

Illustrations:

Recurring trees: pikolorante | Shutterstock
Recurring leaf for skill-level key: Graphic Box | Creative Market
Pages 3, 19, 73, 85, 89 (leaf), 109: Dainty Doll Art | Creative Market
Pages 7, 39, 51, 55, 89 (pine cone), 106, 127: Corner Croft | Creative Market
Pages 11, 82: YesFoxy | Creative Market

Pages 15, 68, 87, 131: Graphic Box | Creative Market
Pages 25, 42, 57, 135, 136: PaperSphinx | Creative Market
Pages 35, 121 (bee): Wonderdigi | Creative Market
Pages 46, 61, 80, 94, 98, 103, 104, 114, 121 (sunflower): Maria B. Paints | Creative Market